BIRMINGHAM UP TOWN

THROUGH TIME

Mac Joseph, Ted Rudge
& John Houghton

AMBERLEY PUBLISHING

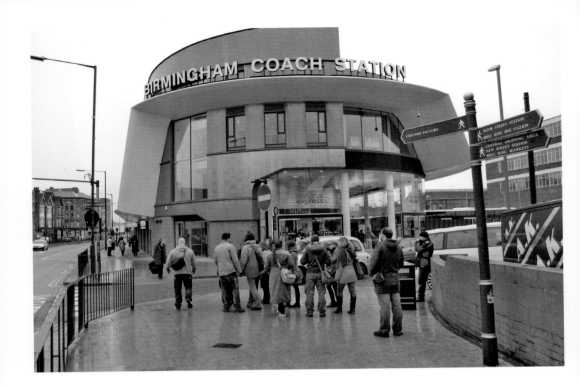

First published 2010

Amberley Publishing Plc
Cirencester Road, Chalford,
Stroud, Gloucestershire, GL6 8PE

www.amberley-books.com

ISBN 978 1 84868 638 0

British Library Cataloguing in Publication Data.

A catalogue record for this book is available from
the British Library.

Typeset in 9.5pt on 12pt Celeste.

Typesetting by Amberley Publishing.
Printed in the UK.

Foreword
by Carl Chinn

As children me and our Darryl were avid readers. On a Saturday morning a regular treat for us was to catch the bus up town, as we called going into Birmingham city centre, and meet Our Nan and her sister, Our Auntie Win. We always made a beeline for Hudson's Bookshop. It was an enchanting place, about half way up the left on New Street as you were heading from the High Street to the Town Hall. When you first went in to Hudson's it was as if there was just one little room, then other rooms or stairways to lower rooms suddenly and amazingly came into tantalising half view from beside the odd bookshelf and counter. Alluringly they beckoned you to seek them out and find the literary delights within them.

With excitement you'd go through a tiny opening or down the stairs to hastily look around another place of wonder and see if this had any of the books that you were so keenly after. Often they didn't and instead were full of incomprehensible academic texts – but even they dragged your fingers to flick through them and try and get some understanding of them. Then it was back to the children's section to find and catch hold of the latest escapade of Biggles, the fictional pilot and adventurer created by W. E. Johns who took us with him to strange places and dangerous locations. In my mind's eye I was one of his pals like Ginger or Algy, ever ready to help him see off dastardly enemies.

And if there was no new Biggles book then I'd be drawn to the section where Rosemary Sutcliff's stories would be lined up as if they were waiting just for me to pull them out and make them my own. Through her often vulnerable yet strong and determined characters it was she who gave me a powerful feel for the end of the Roman Empire in Britain, the coming of the Angles and Saxons, and the legends of King Arthur. With her deep historical research and stories that captivated, Sutcliff guided me through the swirling mists of the Dark Ages and showed me that people were people whenever they lived or whatever the circumstances.

Eventually we were dragged out of Hudson's and we would go with Our Nan and Aunt Win to meet their sister, Aunt Rose. They would take us to the Midland Counties Dairies café in the Great

Western Arcade where we would have sausage, chips and beans. Then there was another treat – a visit to Barnbys on the corner of the Arcade and Colmore Row. Our Kid would look in awe at the models of airplanes hanging from the ceilings, whilst I would make a beeline for the tin soldiers. All the while we'd be telling Our Nan and Aunt Win what we wanted for Christmas – and of course as youngsters we knew that just before that festival we'd be taken to see the only true Father Christmas in the world at Lewis's.

Christmas began with that trip to Lewis's. The winter also included a visit or two with Our Nan to Harry Parkes' shop in Corporation Street for football boots or dubbin. We were all Aston Villa fans and Nan had been going down the match since the 1920s. Harry Parkes had been a famed Villa player and Our Nan greeted him as if she was his closest pal. After the shop closed we would walk with our Nan up to Fountain Court, which seemed to us like the secret garden – another world so quiet and calm and so different from the Birmingham we knew. Then we'd head to the bus stop to go back to Nan's maisonette in Rupert Street, Nechells. It was that time between dusk and nightfall, and all was quiet until there was a noticeable rustling sound above us. It came from hundreds of pairs of wings of starlings as they flew up from their perches on the buildings up by the Victoria Law Courts and into the sky.

As we grew older, we'd go up town with our mates – just having a mooch. Sometimes we'd go to the Bull Ring, other times to the Oasis Market and then from about thirteen or fourteen each and every Tuesday night we'd go to the Top Rank for an under sixteens disco. As our later teens beckoned so too did we graduate to Saturday nights at the Top Rank, with a drink beforehand in the Hole in the Wall or the Costermonger, or else we'd go to the Locarno and occasionally Edwards in John Bright Street.

These are some of my own particular memories of up town. Each and every one of us Brummies will have memories that may seem specific to us alone but yet which will reach out to others of our age. This book by Ted Rudge, Mac Joseph and John Houghton will surely spark them back to life – as it has done for me.

Professor Carl Chinn MBE

Introduction

Visiting Birmingham City centre from anywhere nearby the term 'going up town' is used by a true Brummie. Why do we say town when we are visiting a city? And why do we say going up when all the roads leading to Birmingham centre are not hills (some are but not everyone). The answer could lie somewhere between the origin of Birmingham and the market town it became. In 1166 when Peter de Birmingham decided to establish a market he chose dry land on a hillside away from the River Rea. Traders and customers having crossed the river then had to go up town to get to the market. Of course this is pure speculation but the saying started somehow and is very much part of the local language.

Over the 844 years Birmingham has grown from a small market town into the conurbation we know today. The journey has obviously involved a great many changes – some people would say too many. Buildings and venues that change any city centre are recorded in the memory of those that have experienced them and a total surprise to those returning after a long absence. One such place, up town, has been the Bull Ring market area where following the latest redevelopment even the name was changed to Bullring. Working back through the medium of photography over the last 100 years some of the changes made to the centre of Birmingham have been photographed and illustrated in full colour in this book providing a permanent history of Birmingham (up town).

Three friends who have a great interest in old Birmingham, each with their own website of areas close to the centre of Birmingham, have produced this book. Each author chose a third of the city centre and put together the old and new that seamlessly appears in the book. The trip up town begins where it all began, the market area, and continues in roughly a clockwise direction finishing back at the markets. It has not been possible to include every alteration that took place but hopefully we have covered some of the roads, places and buildings that you went up town to visit. Enjoy the read and we hope the nostalgia rekindles many thoughts you had of your own past trips up town.

Ted Rudge MA

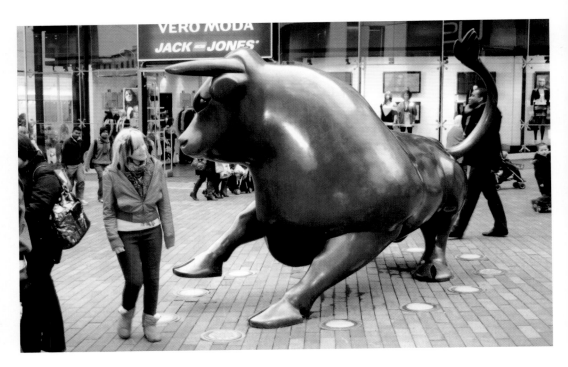

Bull Ring Attractions

Standing among the indoor shops as you enter the west building of the new Bullring from New Street, unmistakably, this seven foot bronze sculpture of a bull created by the British sculptor Laurence Broderick greets the visitor. The bull has been on guard since 2003 and provides a link with the numerous attractions of the old Bull Ring area like the strong man demonstrating his strength to the gathered crowd in a previous age.

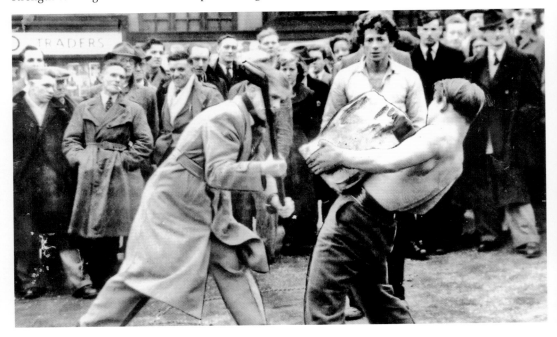

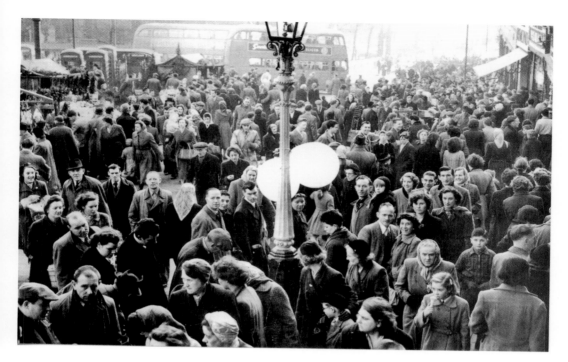

Crowds of Shoppers

Enjoying their hunt for a bargain, crowds accumulate in and around the outdoor market area of the Bull Ring pre 1950. Market traders are gathered on the hill near St Martin's church facing the southerly route out of Birmingham with temporary wooden frameworks over their barrows ready to protect their goods from the elements, ensuring a saleable display for the visitors on both sunny and wet days.

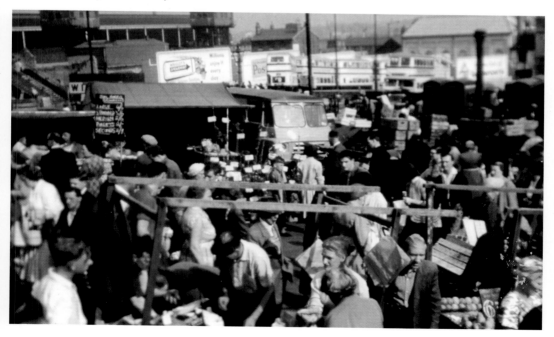

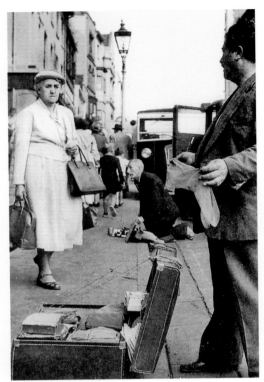

Market Traders Outdoor and Indoor

Two traders selling their goods outside the Bull Ring Market Hall – one from a suitcase, the other selling directly off the pavement whilst kneeling on a piece of sacking. An apprehensive lady is checking the goods from a distance before becoming a customer; both traders would have been on the look-out for market officials in order to make a quick exit if discovered. In 2009 the Bullring traders dressed to celebrate the market charter have permanent overhead cover and some even sell from fridges.

Saint Martin Church

Birmingham's original parish church, now a Grade II* listed building, is a rebuild from previous religious structures that have been on this site since the late thirteenth century. In 1873, the church was demolished and rebuilt by architect J. A. Chatwin. Throughout the life of the church the roads and surrounding buildings have altered a number of times, currently the church is located within the pedestrian area of the Bullring.

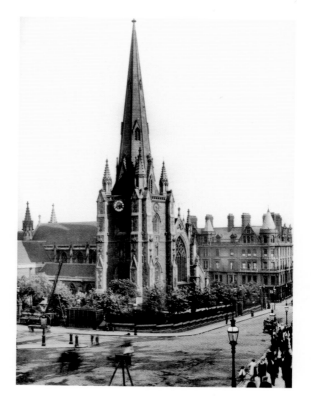

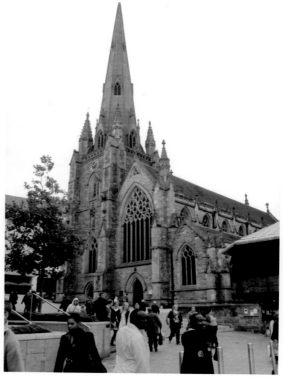

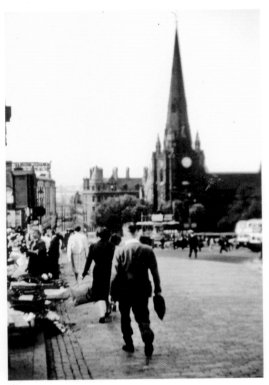

Up Town

Birmingham market area has always been where it is today half way up the hill from the River Rea. This may be one reason why a visit to Birmingham by most Brummies is known as going up town. Looking down towards the river from the balcony of the controversial modern building that houses the Selfridges store today with the church on the right is the road that leads south out of Birmingham (Digbeth and Deritend).

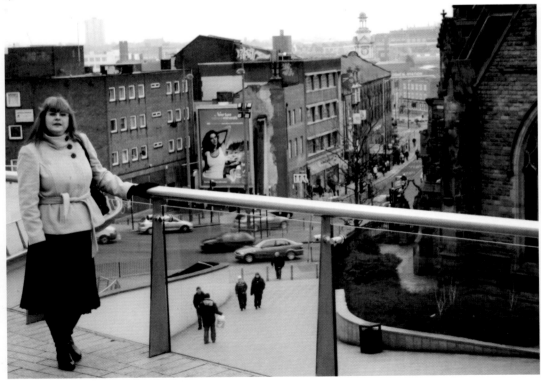

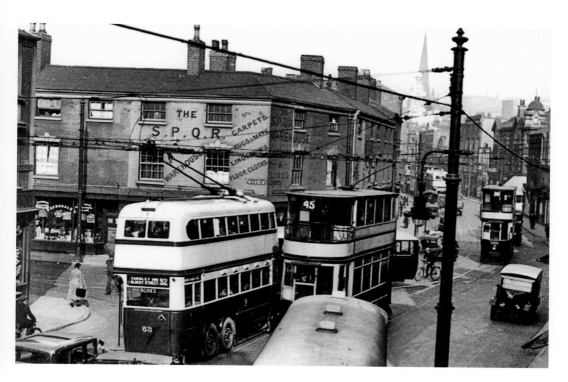

Looking Up Town

Before the road ascends upwards towards the Bull Ring, in the early photograph, St Martin's church is seen towering over a busy transport scene close to the crossing of the culverted River Rea along Digbeth and Rea Street. In 2010 there have been considerable changes to the skyline with the addition of Selfridge's modernistic store, far right top and the Rotunda behind.

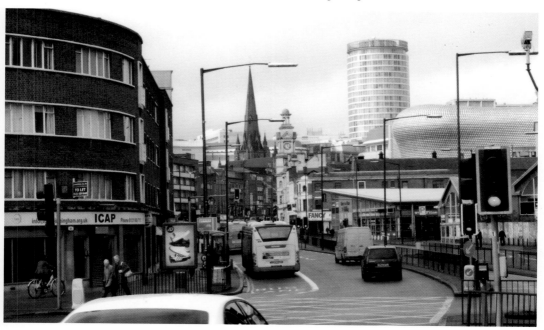

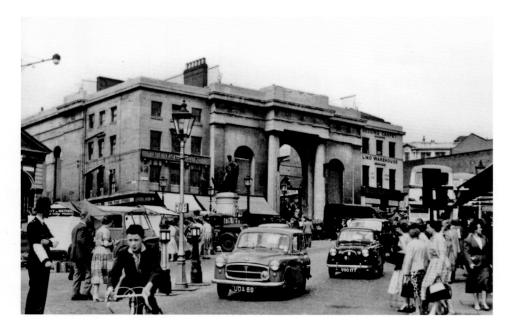

Bull Ring Market Hall

The main purpose the Market Hall was commissioned and built was to bring some order to the congested streets that surrounded the market. Charles Edge the same person who designed the Town Hall designed the Market Hall that was opened on February 12, 1835 containing 600 market stalls; it was demolished in 1963. Today the site accessed from New Street houses a modern shopping area with steps built into the sloping pedestrian walkway that is now home to the recently moved memorial to Lord Horatio Nelson.

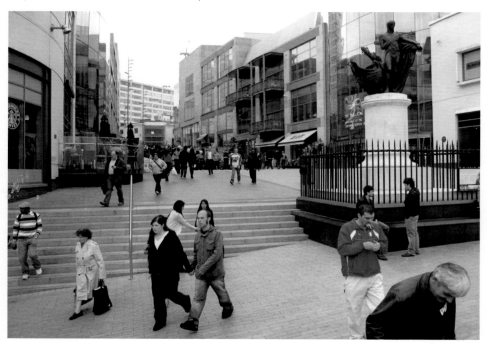

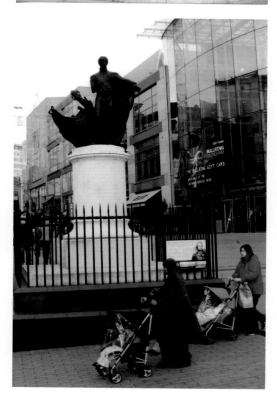

Lord Nelson's Memorial

Erected to commemorate the many naval battles Horatio Nelson fought in defence of England. The statue and its memorial have been moved on a number of occasions to fit in with the various changes made to the Bull Ring area. Like the bottom of the Market Hall steps the monument has served as a meeting place for many generations of Birmingham shoppers.

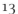

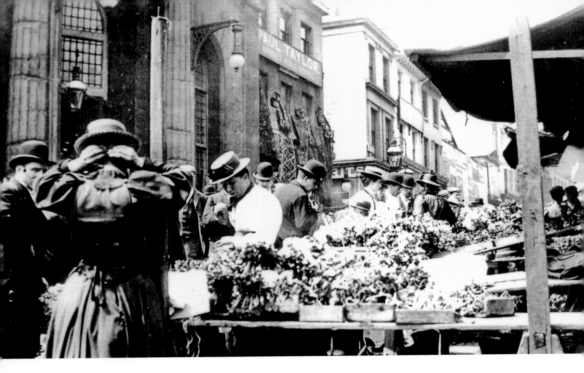

Market Stalls

Over the years the market traders adapted their stalls to suit the purpose of displaying their goods. Some stalls were open hand carts, while others, shown here outside the Market Hall, suspended sheets of wood over wooden trestles with an overhead canopy to provide some protection from the weather. Modern traders now work from permanent stalls covered by translucent archways.

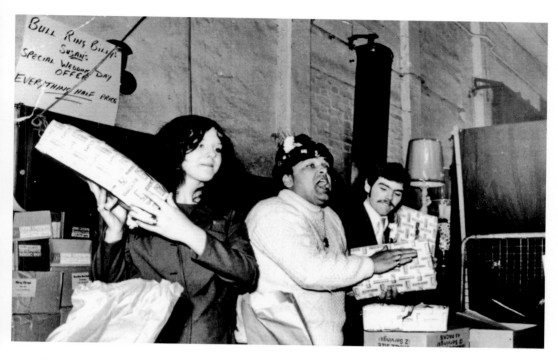

Indoor Market

"Susan's special wedding day offer everything half price" was displayed by 'Bull Ring Billy' in the old Rag Market. Coincidentally another sign in 2009 hanging from the roof supports in the new modernised Rag Market also has a wedding theme.

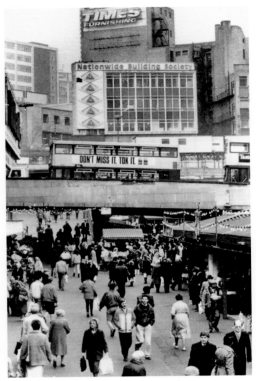

Market Below Ground Level

Following the demolition of the previous market in the late 1950s the area was rebuilt by 1961 placing some market trader stalls below ground level. Shoppers can be seen walking under the road that has a bus travelling above, overlooked by the Nationwide Building Society and Times Furnishing buildings. A previous form of public transport, the tram, shows passengers jumping off before the official stopping point as the tram makes slow progress up the gradient of the Bull Ring.

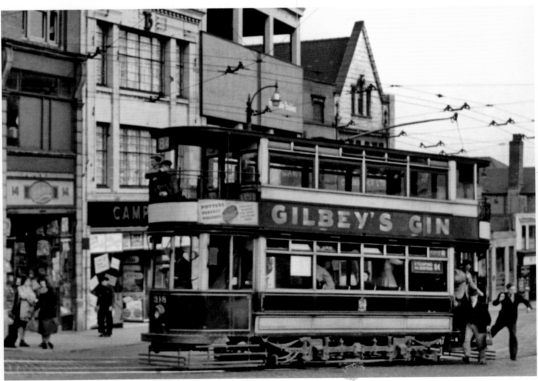

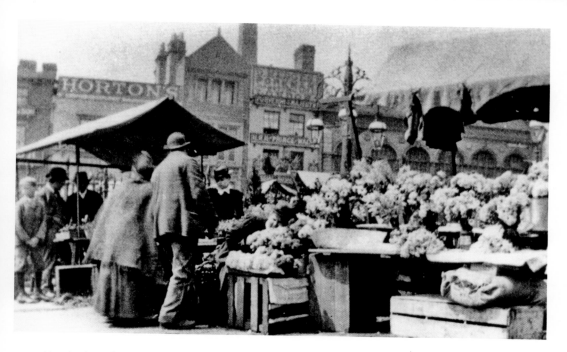

Horticultural Produce

Through time very little change has taken place in the way the Birmingham Bull Ring flower sellers have sold their goods. The images provide a typical scene in the outdoor street market where over the years the displaying of flowers and other horticultural produce has been on temporary tables, hand carts or directly from the ground.

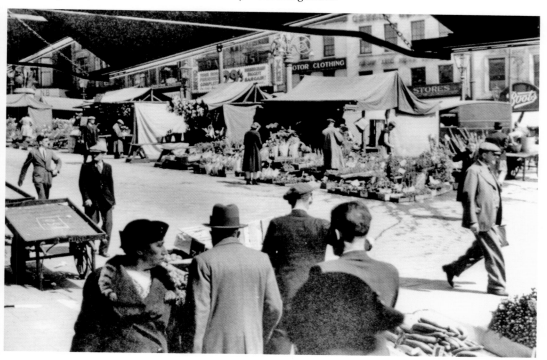

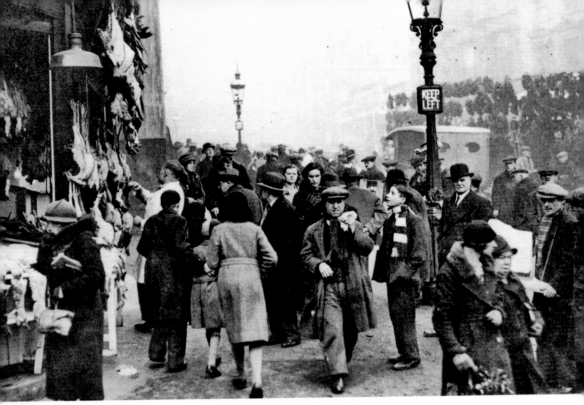

Christmas Fayre

Two scenes of the Bull Ring market, eighty years apart, each leading up to Christmas. In the early one a young boy with a scarf wrapped around his neck looks in wonder at the amount of poultry on display. Facing this across the road holly wreaths and Christmas trees are on sale and in the foreground you can see a lady walking down the sloping footpath carrying her recently purchased sprig of mistletoe. By Christmas 2009 the pedestrians were approaching a smaller outdoor market down the slope from New Street passing Nelson's latest resting point and the church of Saint Martin.

The Rotunda

Towering above the markets from its site at the top of the Bull Ring (Bullring) and the bottom of New Street this Grade II* listed, 266ft tall, cylindrical building was completed in 1965 as part of the new Bull Ring complex. The Rotunda was originally built as a commercial building but has recently been converted into residential high-rise apartments.

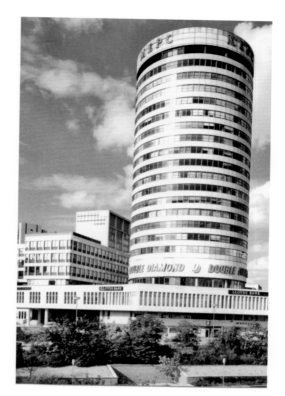

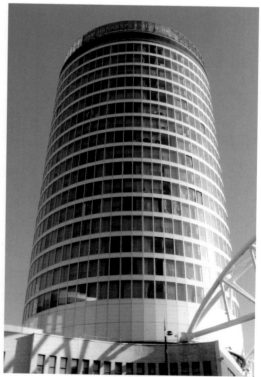

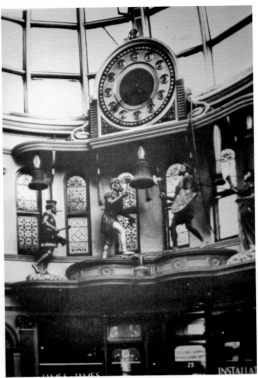

Market Clock

This large clock had four six foot plus figures representing the Earl of Warwick, his Countess, a Constable and a Saracen that was first on view to the general public in a Dale End arcade. Then in 1936 it was repaired and assembled in the Birmingham Bull Ring Market Hall where it proved to be a great attraction until it was virtually destroyed in a fire following enemy action during the Second World War. In 2010 a smaller ornate clock with four figures, one in each corner, can be found suspended from the roof of the indoor meat market.

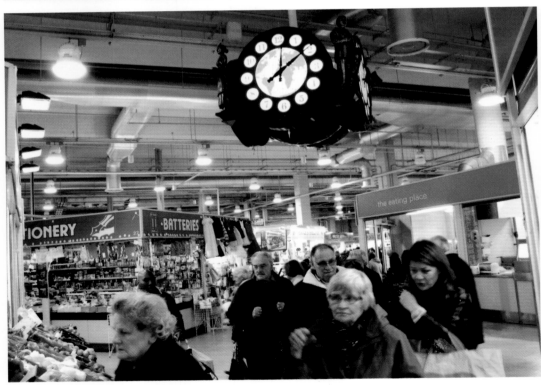

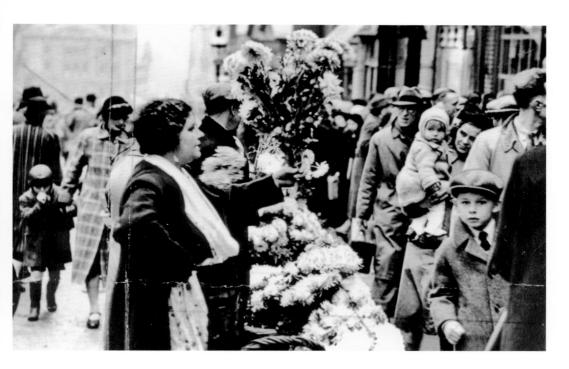

Flower Sellers

A line of flower sellers greet the public in the early photograph, a tradition that is as old as the market. On a very cold January morning in 2010 Katherine Kelly a market trader for over forty-seven years is seen wearing a hat, scarf and coat seated inside a cardboard screen complete with an umbrella. Katherine manages to sell flowers all day long in all types of weather from her pitch outside the rag market.

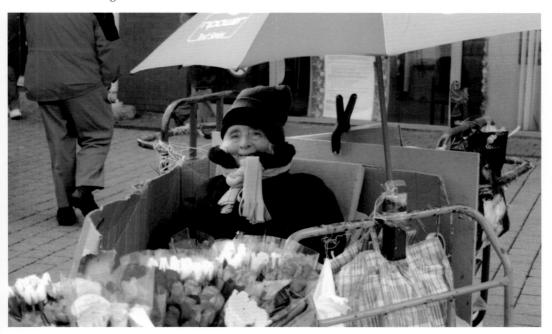

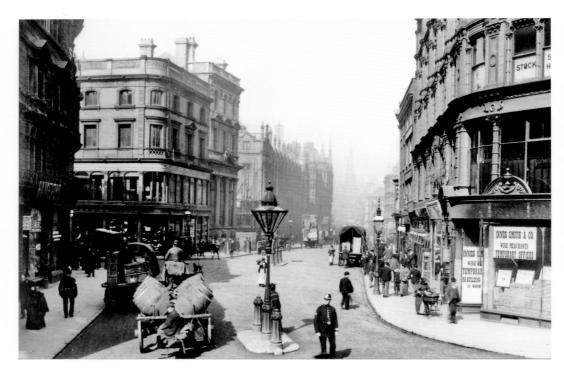

New Street from High Street

This street has been in existence since, at least, the late fourteenth century. A very industrious scene with horse drawn transport proceeding along New Street from High Street is captured in the early photograph. On the left the building with a series of spires on top is King Edwards's grammar school, currently the Odeon cinema occupies the site and New Street is now a pedestrian only area.

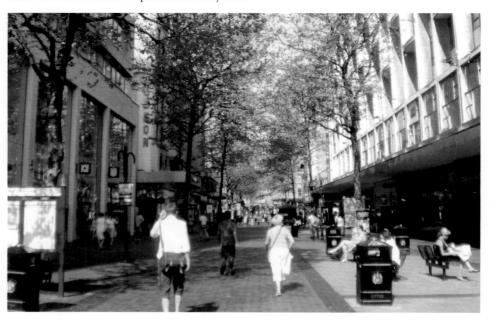

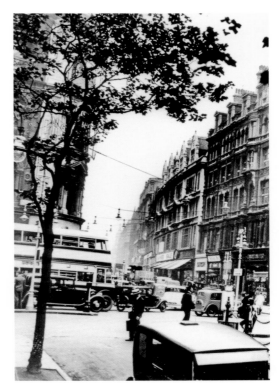

Corporation Street

At the cross road of this busy shopping area viewed from Stephenson Place with New Street Station directly behind more trees have been added. With the buildings now over 100 years old remaining unaltered the passing traffic flow has not. This changed after New Street became a pedestrian only street and now flows one way along Corporation Street into Stephenson Place.

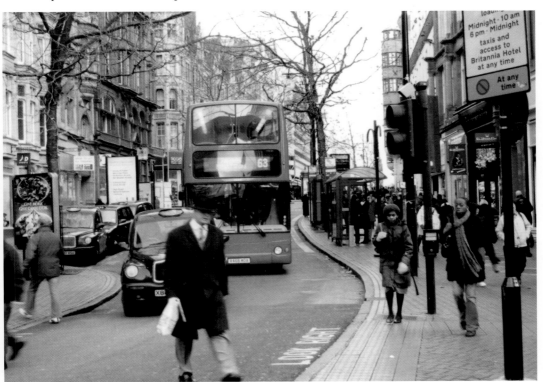

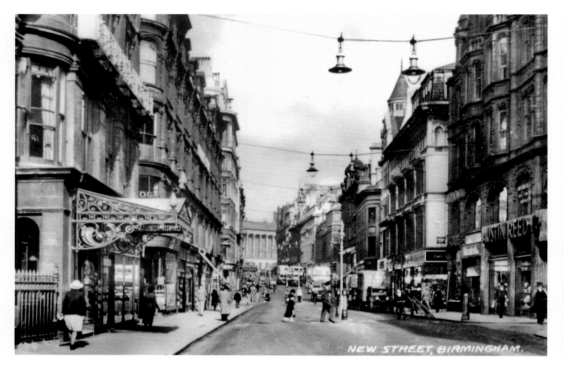

New Street

Birmingham Town Hall at the end of New Street is clearly visible on the early postcard but a large tree prevents this in 2009. Public lighting strung across the street has been removed and with the appearance of modern street furniture and block paving there is a distinctive change in favour of the pedestrian.

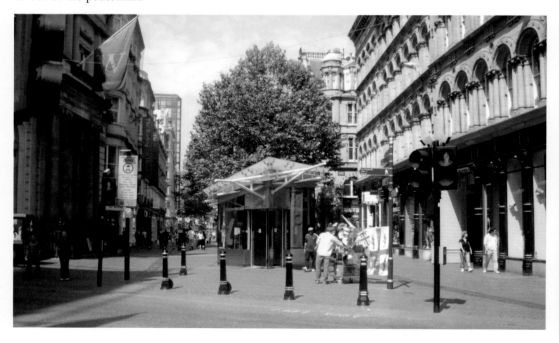

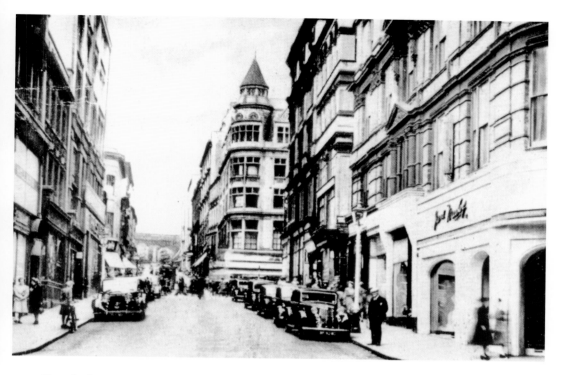

Temple Street

Looking up Temple Street from Lower Temple Street with New Street crossing, St Phillips Cathedral can be seen at the far end. Through time the ground floor shop usage has changed but most buildings have remained as built. The *Birmingham Mail* newspaper seller on the corner of New Street displays the Cadbury headline that day in January 2010 outside the modern Tesco Store.

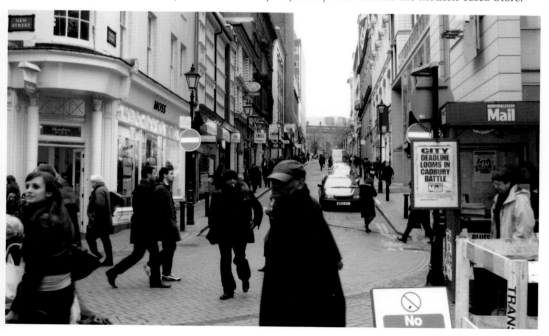

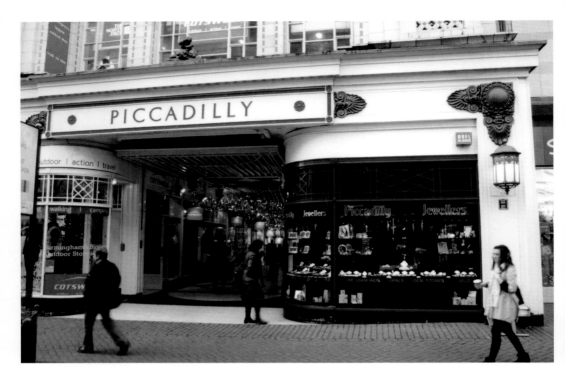

Piccadilly Arcade

Built at the beginning of the twentieth century as a picture house (cinema) but a change of use in 1926 gave New Street this shopping arcade. Above the many retail businesses that line each side of the arcade a series of ceiling paintings by Paul Maxfield are displayed.

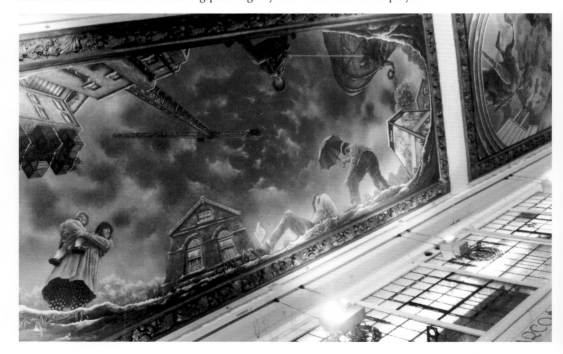

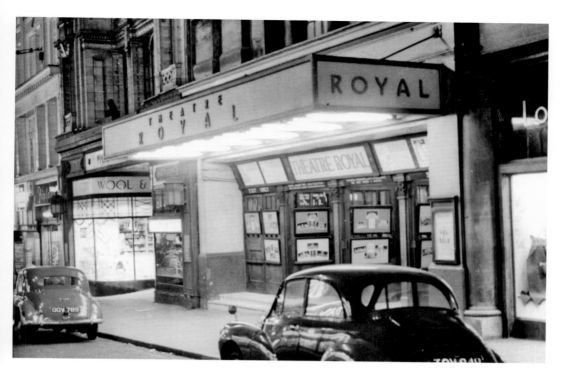

Theatre Royal

Four theatres have over the years existed on this site – the first opened in 1774 and the last the 'Theatre Royal' was demolished in 1957. A Woolworth building followed and that has consequently been demolished. Today a blue plaque has been sited between a drug store and an Italian restaurant acknowledging where the Theatre Royal once was in New Street.

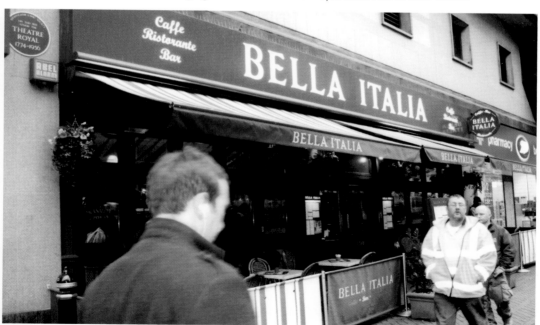

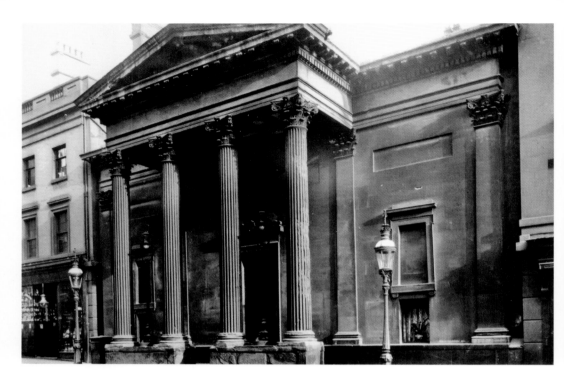

Society of Artists

In 1829 Thomas Rickman designed this neo-classical portico at the entrance to the Birmingham Society of Artists (prefixed Royal from 1868) gallery located at the Town Hall end of New Street. This design is very similar to that of Birmingham Town Hall and Christ Church. The replacement building that followed the demolition of the gallery in the early years of the twentieth century is still in use in 2010.

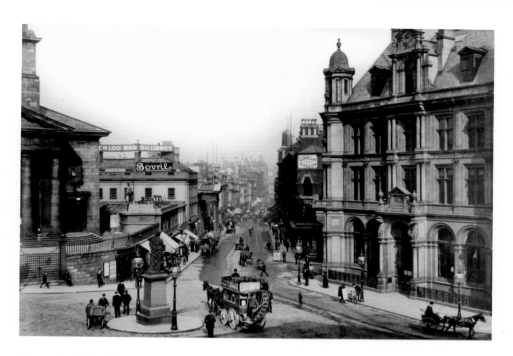

Top end of New Street

Two views of New Street over sixty years apart both looking down from Victoria Square. The early one taken in 1890 has the newly completed post office on the right with Christ Church opposite (demolished four years later) and the Royal Birmingham Society of Artists a little further along. Motor transport had clearly overtaken the horse and cart and the statue of Sir Robert Peel by the later photograph with a new building replacing the church.

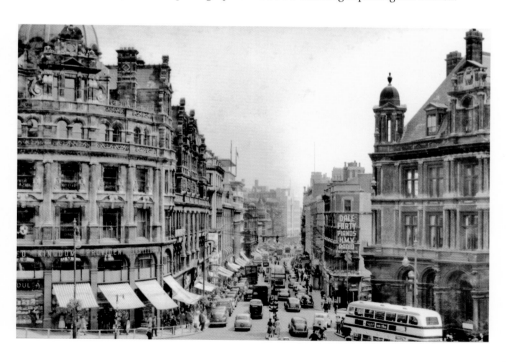

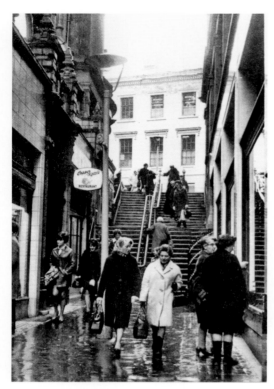

Christ Church Passage

Christ Church Passage named after the church that once stood at the side of this passage-way at the top end of New Street. Two flights of steps provide access for the public between Waterloo Street and New Street. Shops that were once part of this thoroughfare have been replaced by a wall with railings.

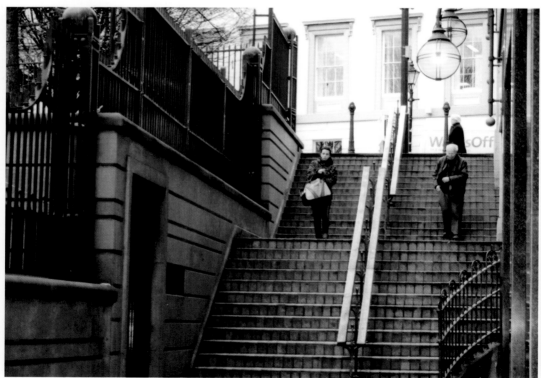

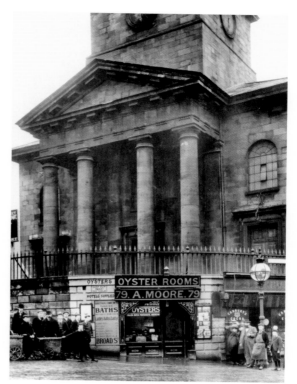

Christ Church

Raised by public subscription in 1805 Christ Church occupied the corner of New Street and Ann Street (later Colmore Row). The church was demolished in 1899 and the remains of the deceased were removed to the Warstone Lane cemetery. Looking over this corner in 2010 is the 20 foot controversial Anthony Gormley rusting creation entitled 'Iron: Man' erected in 1993 and donated to Birmingham by the TSB bank (later Lloyds TSB).

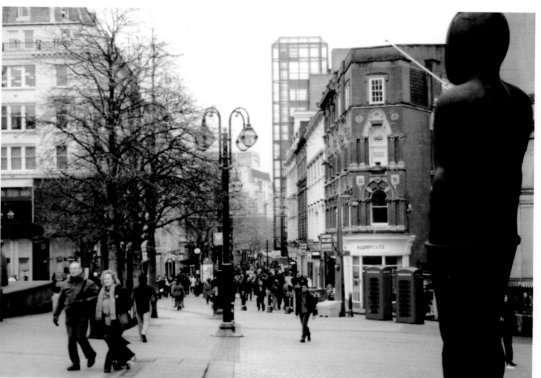

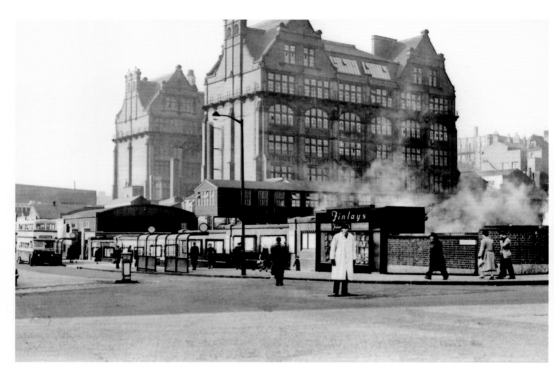

Navigation Street

Matthew Boulton College located in Suffolk Street towers over this part of Navigation Street and Hill Street in the days of steam trains. Steam can be seen rising behind the policeman from the railway that runs under the roadway. Trams once took day trippers from Navigation Street down Bristol Road to the Lickey Hills – now buses cover this journey. High rise buildings and a 1960s concrete signal box occupy the sky line in 2010.

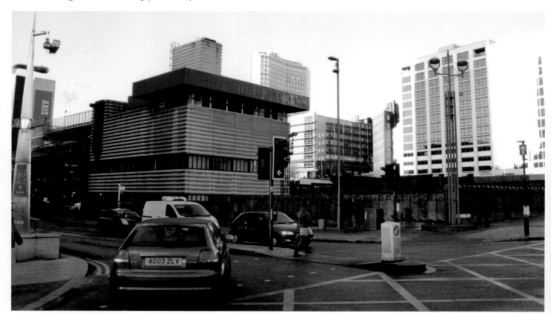

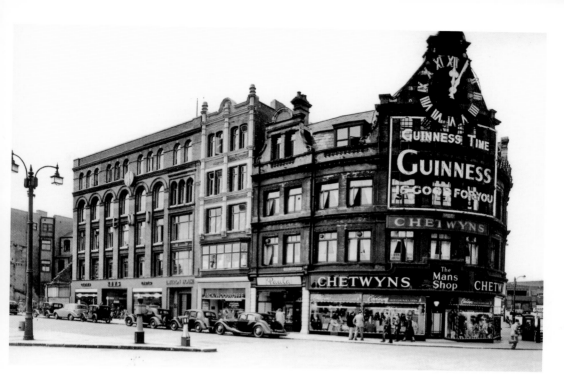

John Bright Street

An outstanding advert with a large clock embellishes this attractive building on the corner of Navigation Street and John Bright Street above Chetwyn's shop for men. Only one part of the old building, on the left, has survived and is now joined up with the new Orion Building on this corner. The large building behind the Orion is located in Suffolk Street.

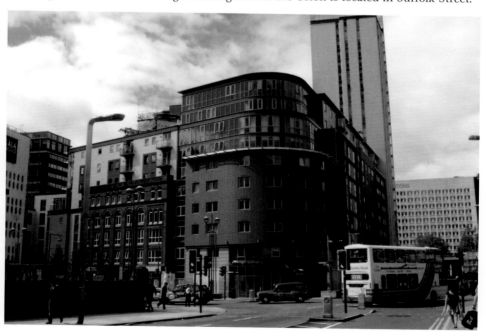

Queens Drive

New Street Station railway complex occupies much of the underground part of this area. Looking over the wall behind the far traffic light reveals a multitude of rail lines.

Prior to this recent development Queens Drive cut through at this point providing an alternative route for the visitor to the station and the Bull Ring area.

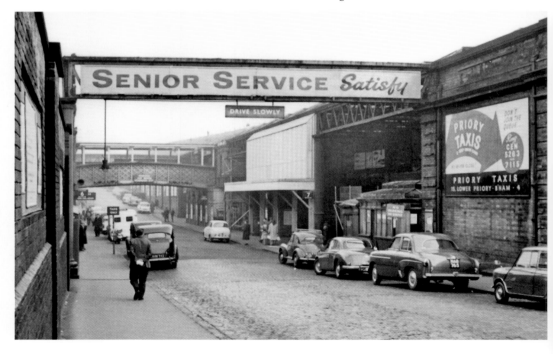

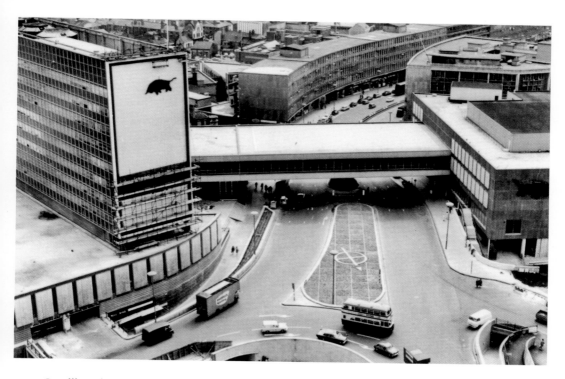

Smallbrook Queensway towards the Bull Ring

The early photograph was taken from The Rotunda and shows the approach road to the Bull Ring from Bristol Street and Holloway Head a motif of a bull is displayed on a building on the left hand side. In 2009 the Rotunda towers over the pedestrian bridge displaying the words BULLRING. The various indoor and outdoor Bullring markets are located beyond the Debenhams store to the right.

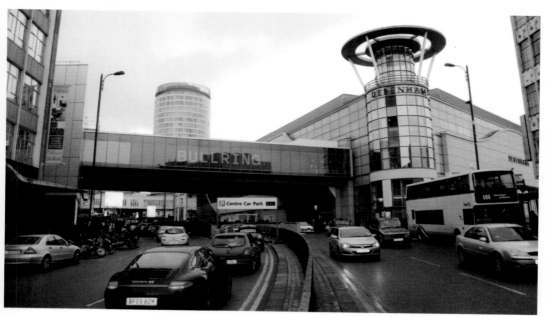

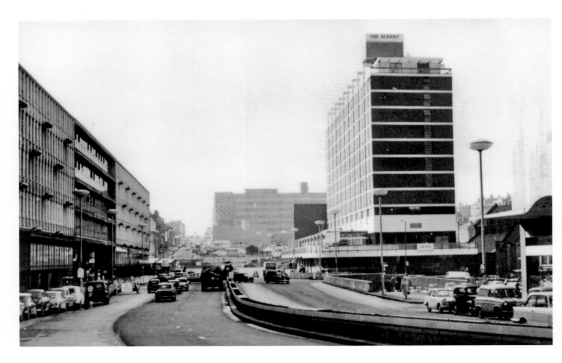

Smallbrook Queensway – Holloway Circus

Smallbrook Queensway leading to Holloway Head, in the sixties photograph it shows the Albany Hotel, the building is still there today. The tall blue building is the new Radisson Blu Hotel on Holloway Circus, near the corner of Suffolk Street. Towering above the city centre the Radisson was built on the site of the former TGWU Building and Gino's restaurant. Shops and offices on the left hand side have changed very little over the years.

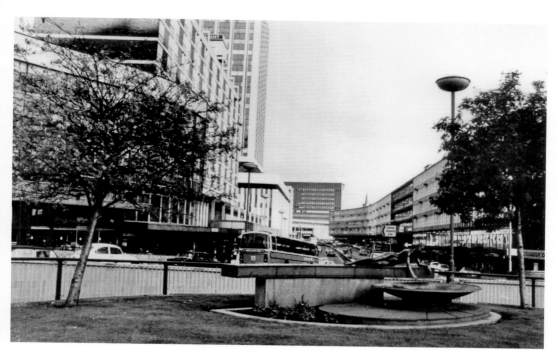

Smallbrook Queensway from Holloway Circus
Blue glass windows of the Radisson Blu Hotel dominate and brighten this corner. A Chinese Pagoda donated to the city was unveiled here in 1998 forming a landmark for the nearby Chinese Quarter. The pagoda was carved in Fujian, a province of China, and replaced a stone statue of a female relaxing in the cultivated centre of the Holloway Circus roundabout.

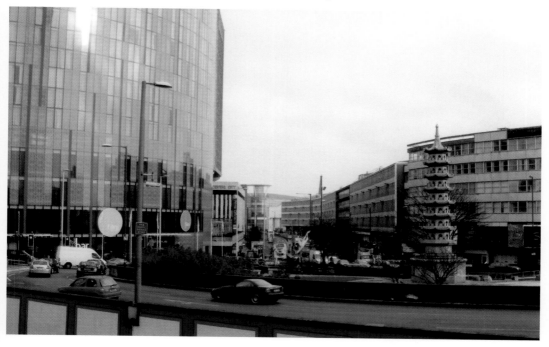

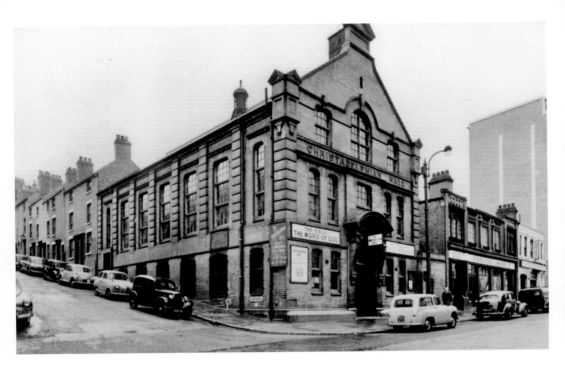

Christadelphian Hall

Located in Suffolk Street, on the corner of Gough Street the Christadelphian Hall now the UCKG help centre is dwarfed by The Cube, a large ugly building located behind. A little way to the right is the shopping centre called The Mailbox that also houses the BBC. All the Victorian back-to-back and terrace houses have been demolished in this area in favour of the many modern high rise buildings.

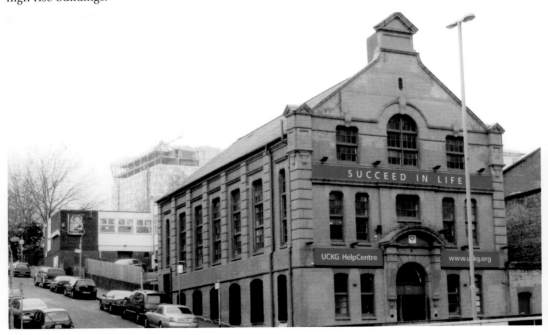

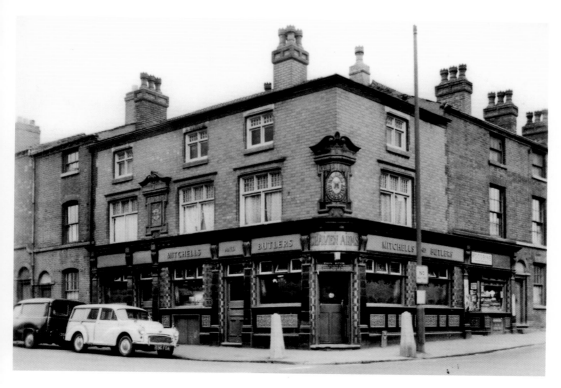

The Craven Arms

One building that has survived the redevelopment of this area is The Craven Arms a public house on the corner of Blucher Street and Gough Street. Although the houses, shops and small businesses have disappeared and were replaced by industrial units, this building has managed to maintain its beautiful blue Victorian tiled exterior.

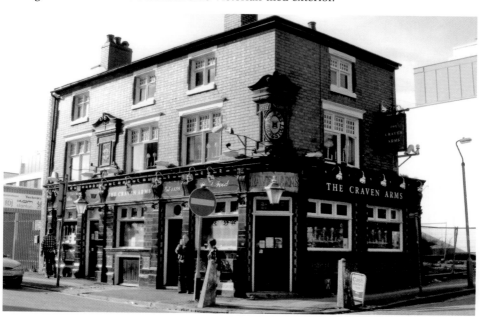

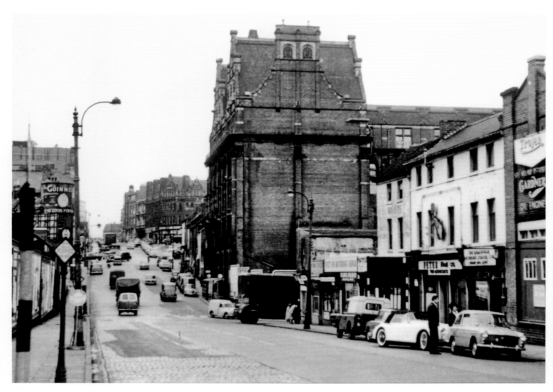

Suffolk Street Queensway

Suffolk Street is now prefixed with Queensway and was the home of Matthew Boulton College the large building on the right of the old photograph it was founded in 1893 as the Birmingham Municipal Technical School. Following redevelopment in the late 1950s the college was demolished and a dual carriageway built with under and overpasses forming part of the main through route of the city.

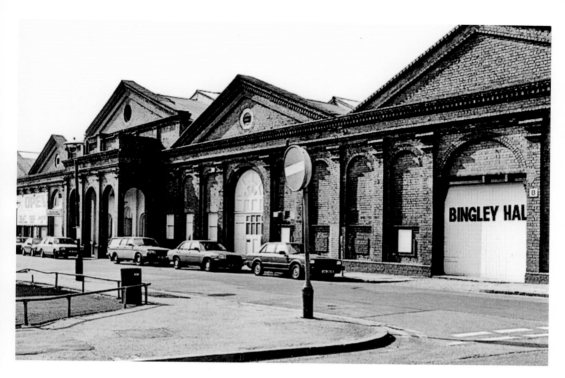

International Convention Centre

Bingley Hall was a major venue in Birmingham for over 130 years; eventually closing its doors for good and was demolished in the mid 1980s. The International Convention Centre (ICC) now occupies the site and was opened on 12 June 1991 by Queen Elizabeth II. The ICC was erected on the north side of Broad Street, immediately next to the Repertory Theatre and is now a part of the entertainment scene in Broad Street.

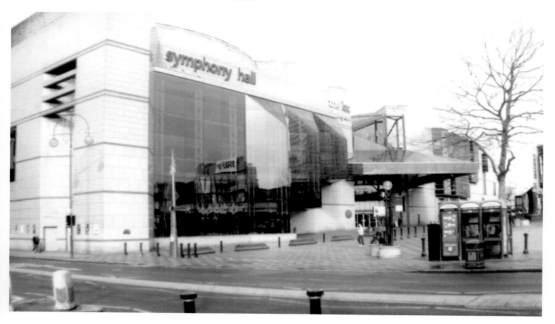

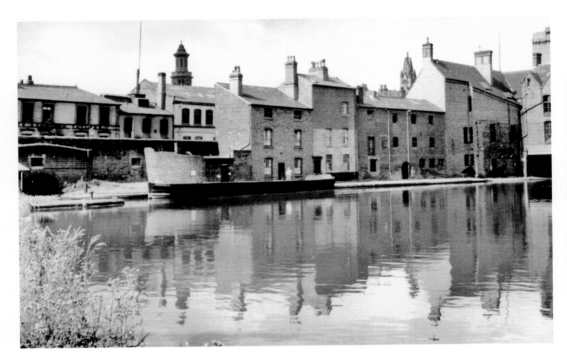

Gas Street Basin

Birmingham's end of the Birmingham to Wolverhampton canal terminates at this basin, cut during the later part of the eighteenth century. The canal which cuts under Broad Street, leading to the International Convention Centre and National Indoor Arena is no longer used to transport cargo. Pleasure crafts frequent the canal now and the area has become a very popular tourist attraction featured in many films and television programmes.

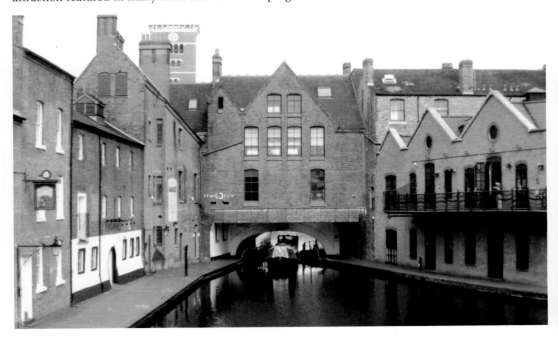

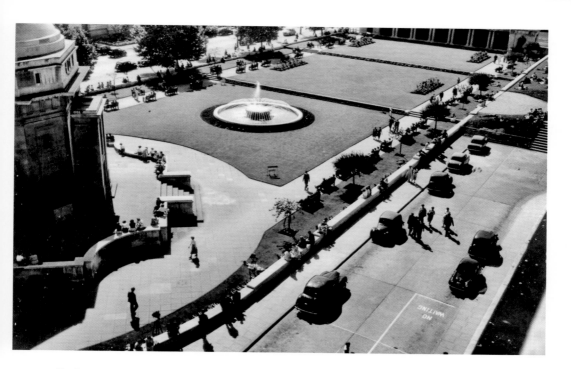

Hall of Memory and Centenary Square

An aerial view of The Hall of Memory with a lawn, fountain and a covered seating area located at the far end of Broad Street opposite the Register Office. Many newly married couples had their wedding photographs taken on the lawn by the fountain.

Centenary Square now occupies this land with the Hall of Memory included together with the International Convention Centre, Symphony Hall and the Repertory Theatre.

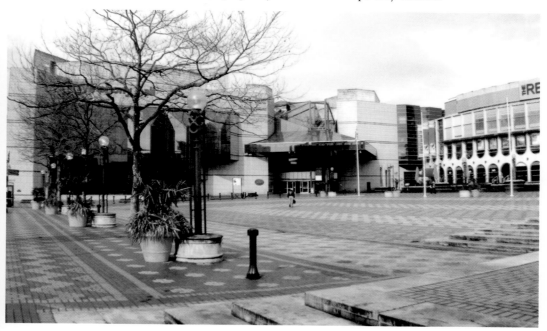

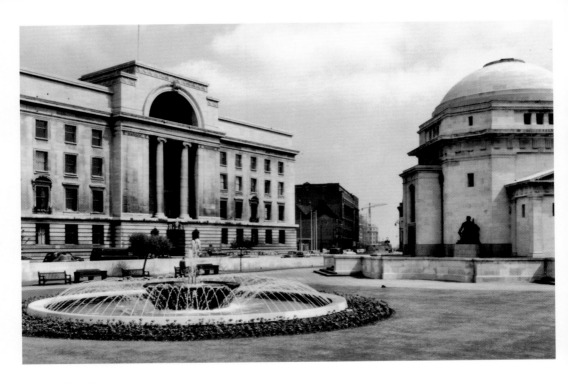

Baskerville House

In the 1920s this Broad Street site was a collection of factories, warehouses and canal wharves. Birmingham council intended to create a vast civic square with prestigious buildings there but following the outbreak of the Second World War the project was shelved. Only Baskerville House and an arcade were completed alongside the Hall of Memory.

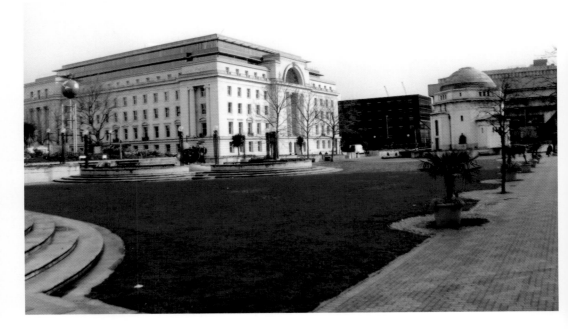

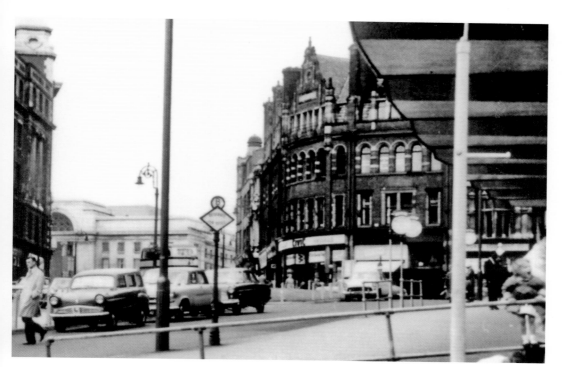

Easy Row

Easy Row that ran from the north end of Suffolk Street to Cambridge Street was demolished in the 1960s when Paradise Circus and a pedestrian underpass was created. Easy Row was lost to Birmingham alongside the magnificent Woodman Public House with its glorious ornate pillars and interior decoration, as well as the Civic Radio Services who sold gramophone records.

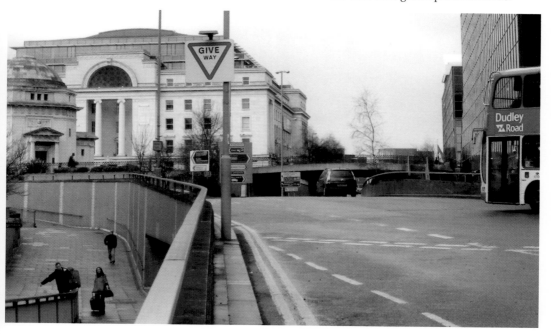

Kunzle's Corner and West End Dance Hall

Snobs now occupy the corner of Paradise Street Queensway and Suffolk St Queensway where the Kunzle's Café stood in the 1960s. On the opposite corner the white walls of the Grand Plaza Hotel now take up the site of the West End Ballroom that once attracted many thousands of Birmingham couples, dancing to live bands of the past.

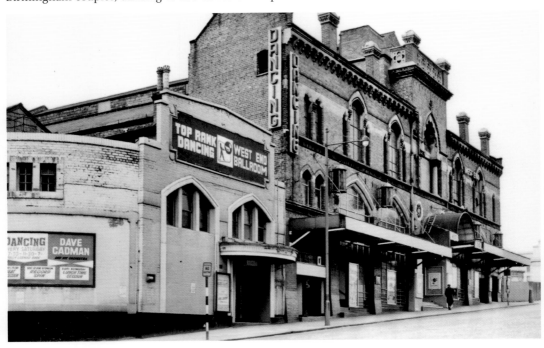

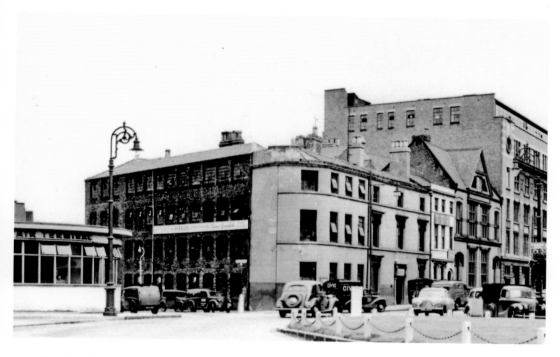

Air Terminal

The Air Terminal building in Easy Row near Baskerville House was demolished during the redevelopment of the area in the 1960s. Paradise Circus Queensway was cut through at this point branching at the end to Great Charles Street on the right and Summer Row leading to Spring Hill and the Jewellery Quarter on the left.

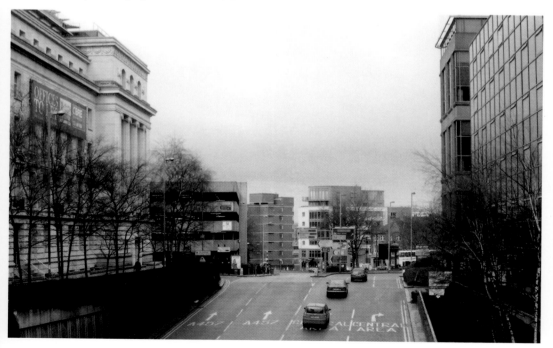

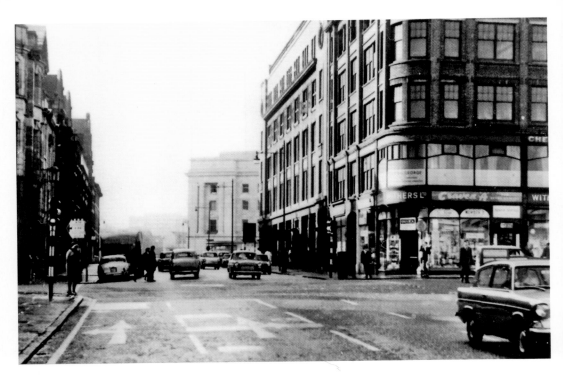

Congreve Street

Congreve Street where it once crossed Great Charles Street with Withers the tobacconist on one corner was demolished to make way for Paradise Circus Queensway in the 1960s. The Birmingham Wheel erected in Broad Street for a three month period at the end of 2009 can be seen at the end of Great Charles Street now a dual carriageway carrying traffic towards the Queensway tunnel.

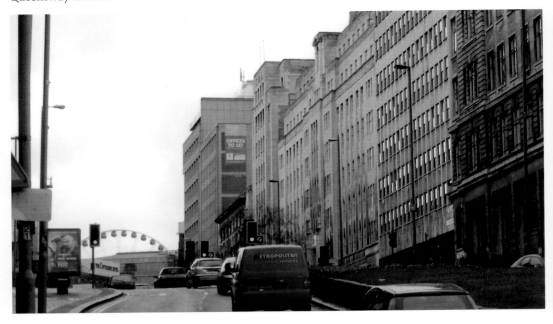

Chamberlain Square

Mason's College, the building in the early photograph, was granted university status in 1900 it opened in 1880 the same year the Chamberlain Memorial Fountain a Grade II listed building was inaugurated to commemorate Joseph Chamberlain's mayoralty. Birmingham Central Library replaced the college and has joined the Birmingham Conservatoire, Birmingham Town Hall and the Birmingham Museum around the Gothic fountain in Chamberlain Square.

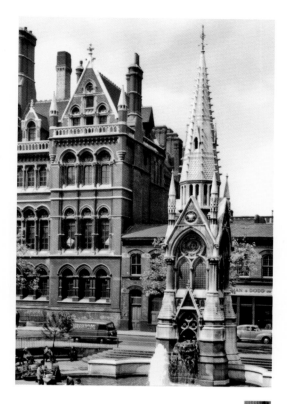

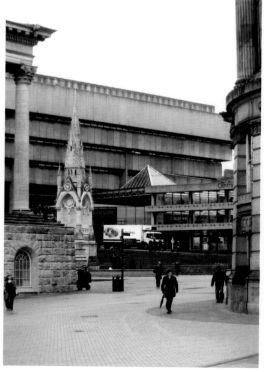

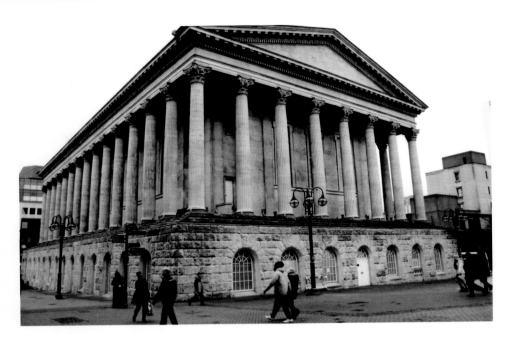

Memorial

In St Phillips churchyard at the Temple Row–Cherry Street entrance there is a memorial that has been constructed as a stone pillar and base the stone looks the same as that used in the construction of Birmingham's Town Hall. The grave stone has the following inscription inscribed on it "John Heap who was killed by accident on January 26 1833 aged 38 yrs while assisting building the Birmingham Town Hall also William Badger who was killed by the same accident aged 26 yrs".

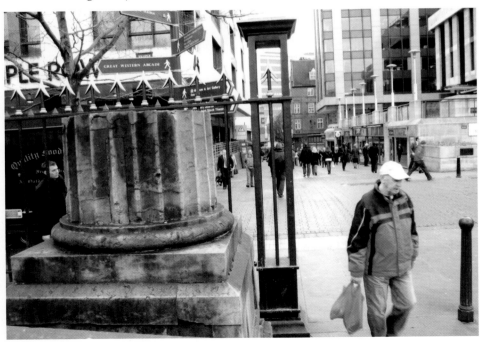

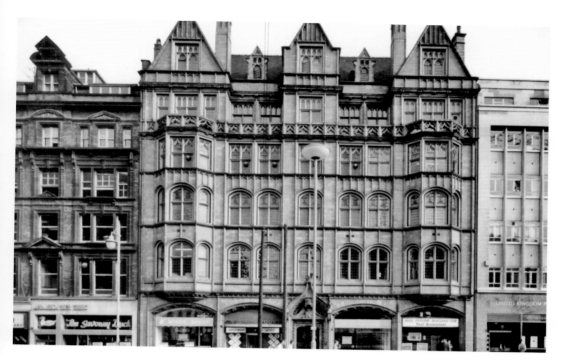

Paradise Street

Very little external change is noticeable opposite the Birmingham Town Hall in the renamed Paradise Street (now Paradise Circus Queensway) which runs from Victoria Square to Suffolk Street (Queensway) where the former site of the Queen's College was location. Today the Grade II listed 1904 façade is known as Queen's Chambers and fronts a residential property. Number 25a Paradise Street used to be the offices of the Birmingham Borough Labour Party in the 1960s.

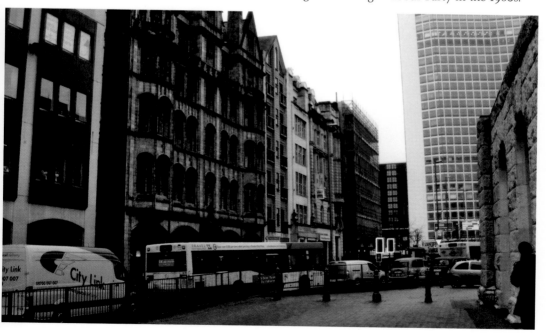

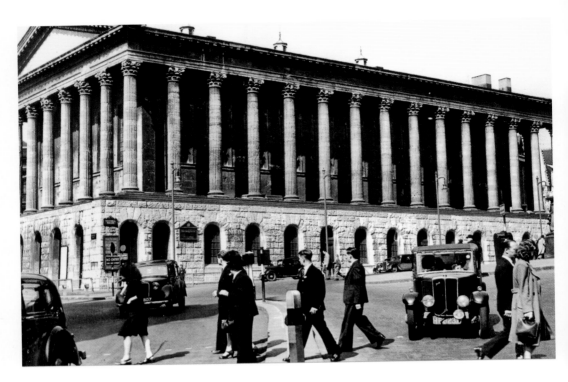

Town Hall

Birmingham Town Hall is a Grade I listed building that was first opened on 7 October 1834. Over the years it has been used for many varied functions but its prime use has been for concerts and meetings. The early photograph with the motor cars passing demonstrates what a majestic building the town hall is. Between 2002 and 2008 the town hall underwent considerable refurbishment and now stands in the pedestrian area that is Victoria Square.

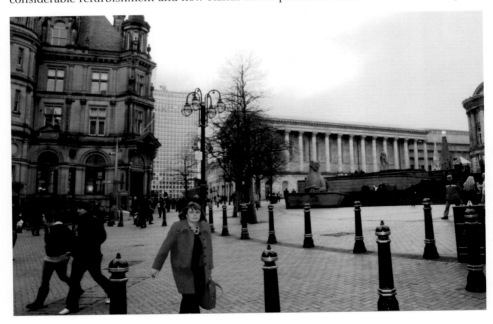

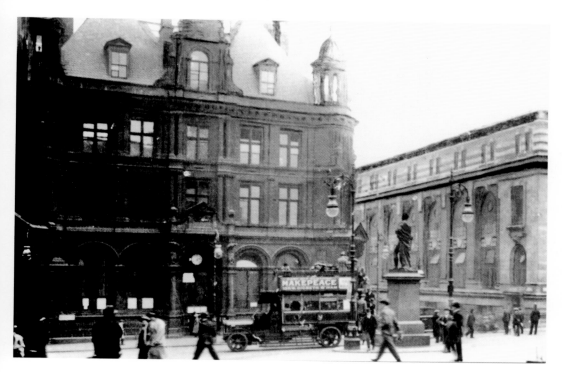

Post Office

Looking more like a French château the General Post Office building in Victoria Square on the corner of Hill Street was designed by Sir H. Tanner and opened in 1890. Ironically the statue in the early twentieth century photograph has been replaced in the 1990s by 'Iron: Man' an Antony Gormley creation. Traffic flow has also changed enabling a pedestrianised area to be established.

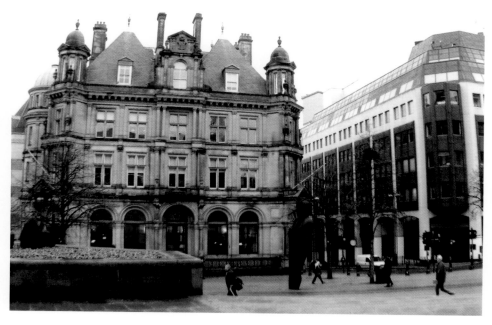

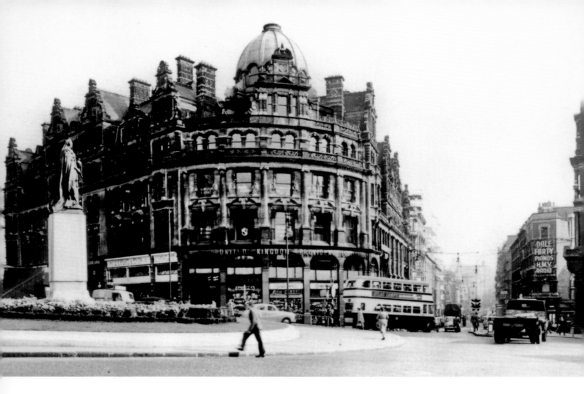

New Street

Two contrasting images are shown of the top end of New Street where Galloways Corner continued into Colmore Row overlooked by Victoria Square. Heavy road traffic has given way to pedestrianisation together with a new building on this corner. Queen Victoria's statue has moved to a new position in the square and Dale Forty Pianos on the right of New Street has been replaced by a series of modern shops.

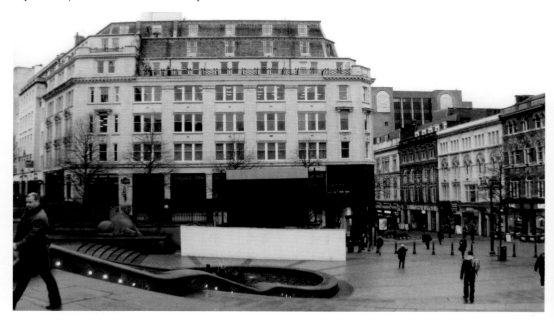

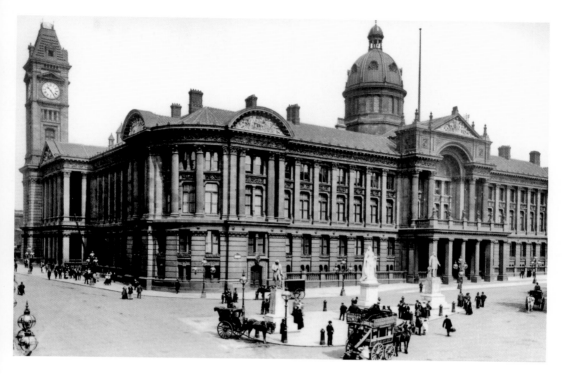

Council House

Victoria Square with the Grade II listed Council House in both photographs, many years apart, provide the background to the 'Floosie in the Jacuzzi' water feature that was added during the redevelopment in 1993. The area and steps provide access to Broad Street, Birmingham Town Hall, Chamberlain Square, Birmingham Central Library and Birmingham Museum and Art Gallery.

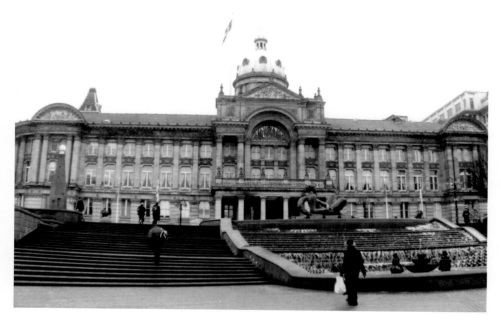

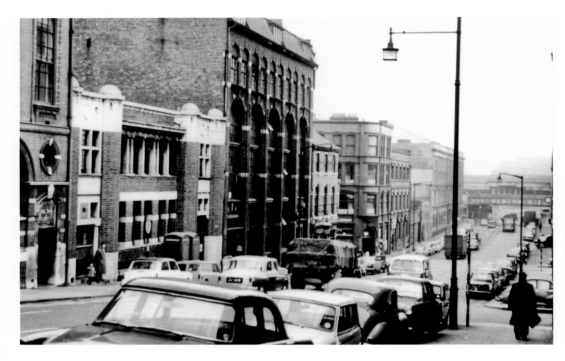

Great Charles Street

Great Charles Street in the early photograph slopes downward towards Livery Street, passing the Dental Hospital on the left and under the railway bridge to Snow Hill. Through time Great Charles Street has become a dual carriageway that passes under a pedestrian bridge (see insert) before joining a subterranean tunnel called the Queensway taking traffic away from Birmingham towards the North.

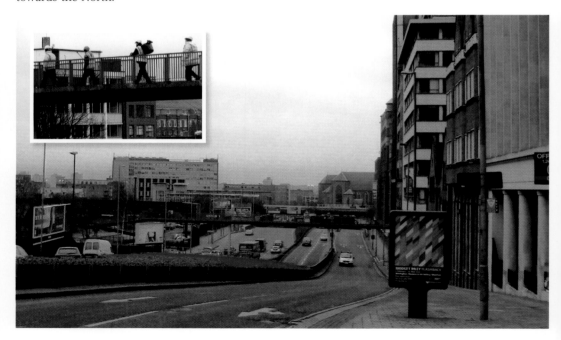

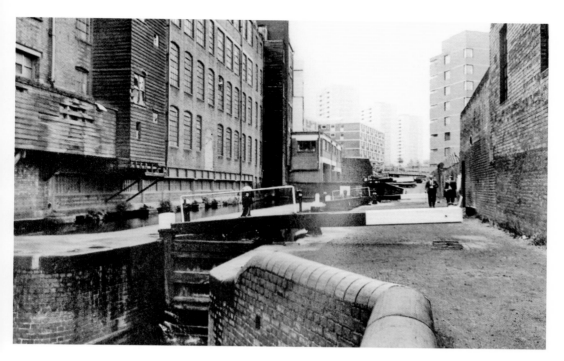

Canal Locks

Canal locks raising and lowering the Birmingham to Wolverhampton canal between Newhall Street and Summer Row on its way to Broad Street. When viewed in 2009 along the reverse direction where the old canal side warehouses have been removed and replaced by modern high and low rise accommodation, the sky line reveals the British Telecom (BT) Tower in the distance.

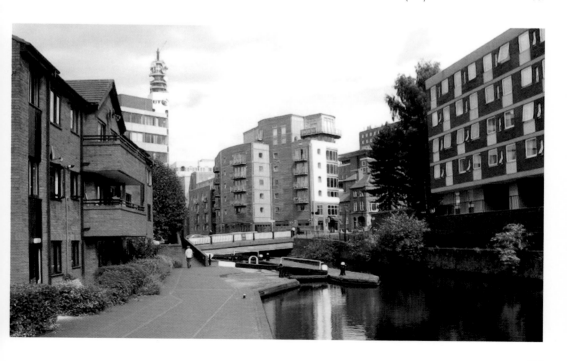

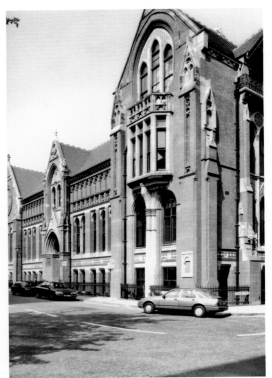

Margaret Street

The Birmingham School of Art is situated in Margaret Street. This Venetian Gothic red brick building was purpose built in 1844 and is located in the city centre's museum and art gallery area. Wood interiors, stained glass windows and mosaic floors have been retained following refurbishment in 1995. Part of the building was used for the School of Printing in the 1960s later moving to Gosta Green.

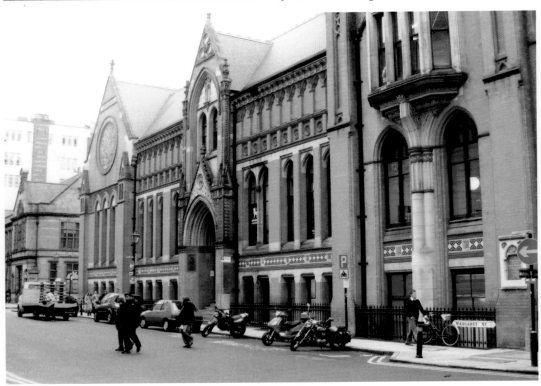

Eye Hospital

The Birmingham Eye Hospital which opened in 1884 on the corners of Barwick, Church and Edmond Streets has been converted into the sixty-six-roomed Du Vin Hotel and restaurant. This early Victorian red brick terracotta building has retained many of the original features including the sweeping staircase and granite pillars.

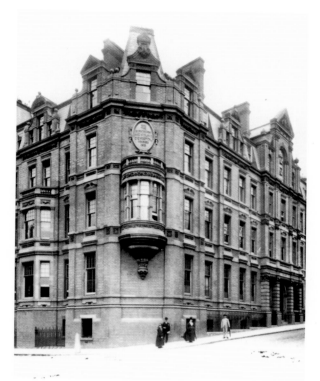

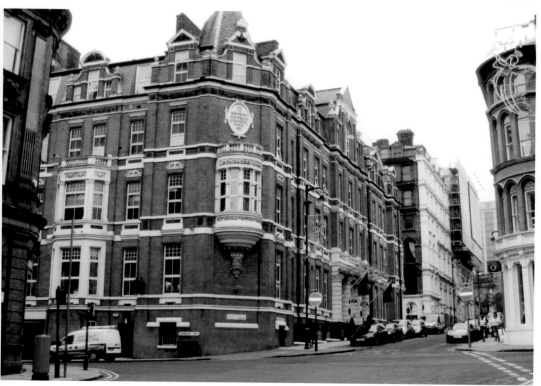

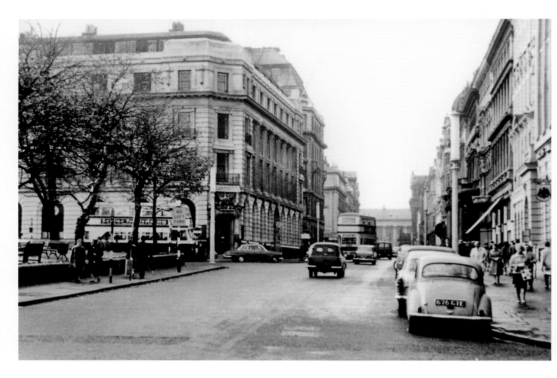

Colmore Row towards Temple Row West

Colmore Row is in the heart of the business and financial district of Birmingham where most of the buildings are Victorian. The frontage of Birmingham's St Phillips Cathedral is also located in Colmore Row where railings have recently been restored enclosing the churchyard that contains many mature trees.

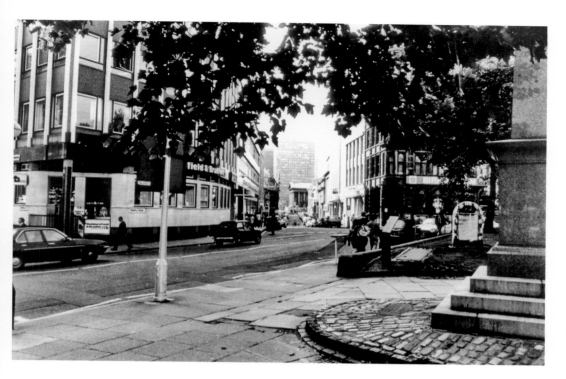

Waterloo Street

Only slight changes have been made to the buildings viewed from Temple Row towards the Town Hall, this street contains some beautiful buildings like the old Grade II listed Midland Bank which is now a Banking Hall on the corner of Bennetts Hill along with the Grade II* National Provincial Bank of England which was established in 1833.

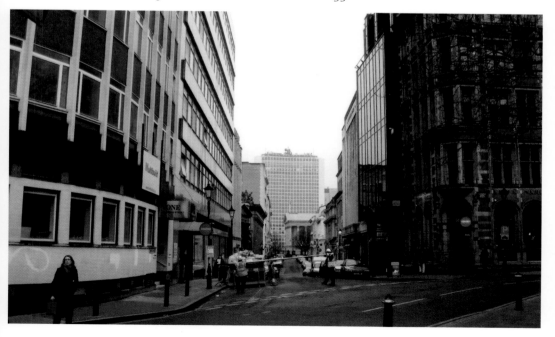

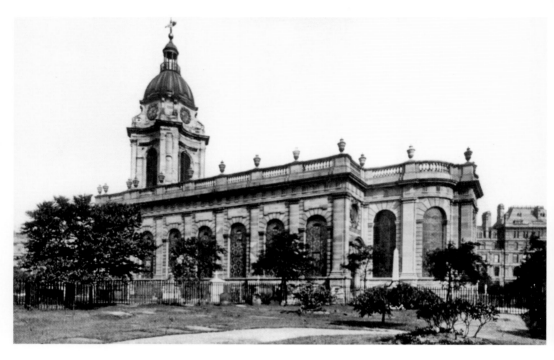

St Phillips Cathedral

Two views of St Phillips. The early one facing Temple Row is a postcard with the words 'The Cathedral Birmingham' attached. Originally the church was built as a parish church in the early eighteenth century and was consecrated in 1715; later in 1905 this Grade I listed building became a Church of England cathedral. A second view taken from Colmore Row shows the Cathedral grounds have undergone restoration that reinstated railings around the perimeter that were removed during the Second World War.

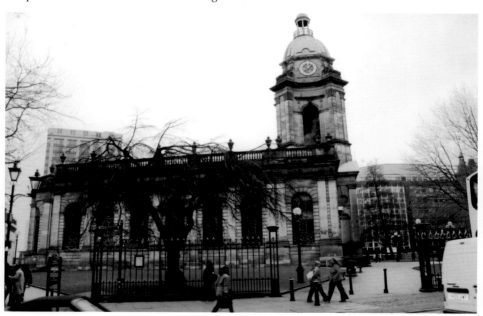

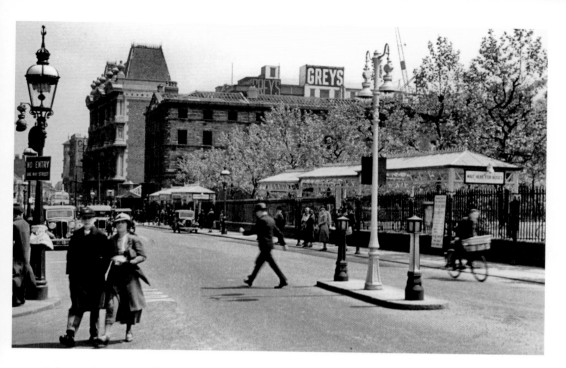

Colmore Row towards Snow Hill

Grey's department store in Bull Street is no longer there in the modern photograph but a row of bus stops along Colmore Row outside St Phillips churchyard appear in both. Across the road the Grand Hotel building built in 1875 and currently a Grade II* listed building no longer operates as a hotel. Through the front entrance a sandwich business has been established and the rest of the building is covered in scaffolding.

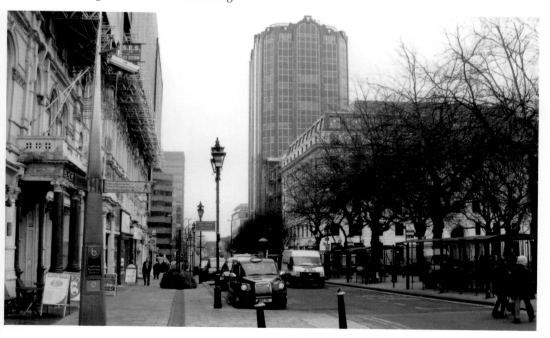

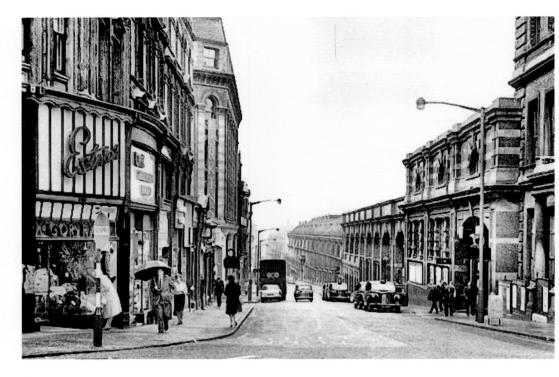

Livery Street

Reputed to be the longest street in Birmingham and that's where the saying and song "A face as long as Livery Street" comes from. The original Snow Hill railway station was built in 1852 on the corner of Colmore Row and Livery Street and demolished in 1977. The station was later brought back into use and a new station was built, on the same site, with a car park entrance on the right behind the bus in the latest photograph.

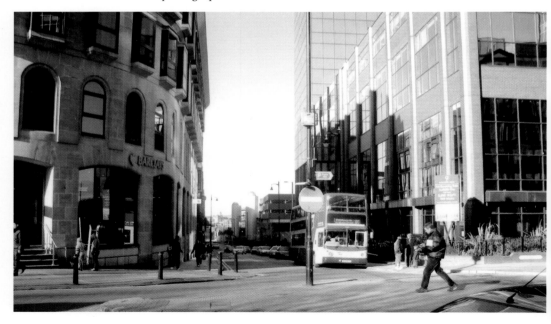

Great Western Arcade frontage
Opposite Snow Hill Station is the entrance
to the Great Western Arcade, a new
frontage exists now following the removal
of the old shops in Colmore Row. The
arcade began as a Victorian show piece but
has been rebuilt several times. Barnaby's
Toy Shop was always a must for children to
visit and the Kardomah café was a popular
meeting place. Both were once located at
the entrance. Lewis's department store can
just been seen in the background.

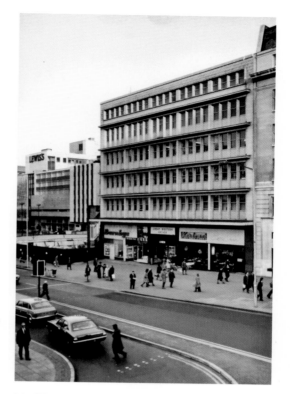

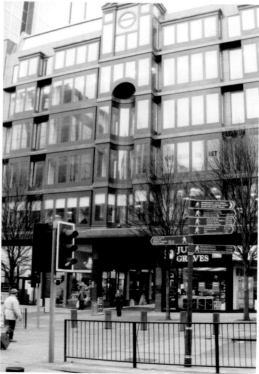

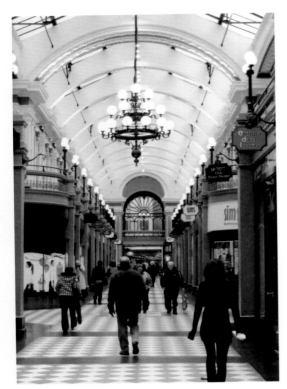

Great Western Arcade
The Great Western Railway Company
built the Arcade between 1876 and 1877
above the tunnel between Moor Street and
Snow Hill stations. The arcade contains
many shops and is worth visiting just to
see the architecture; the walk through
to Temple Street has been restored to its
original build.

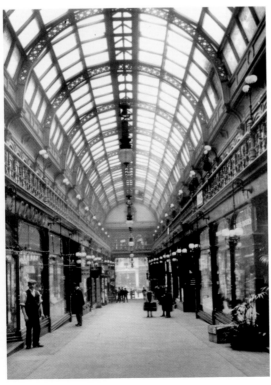

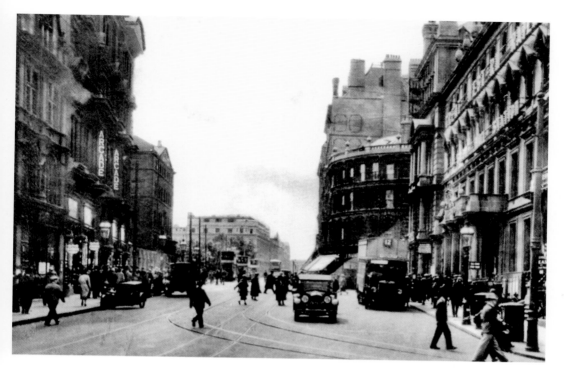

Colmore Row

Outside the Great Western Arcade towards the Town Hall, a mixture of transport vehicles including an omnibus, trams, cars and a motor bike are able to drive up and down Colmore Row. By 2010 street furniture and bus shelters dominate this part of Colmore Row where like many other city centre streets have become one way to the traffic flow.

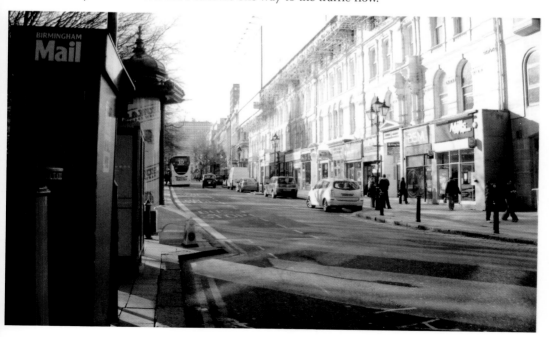

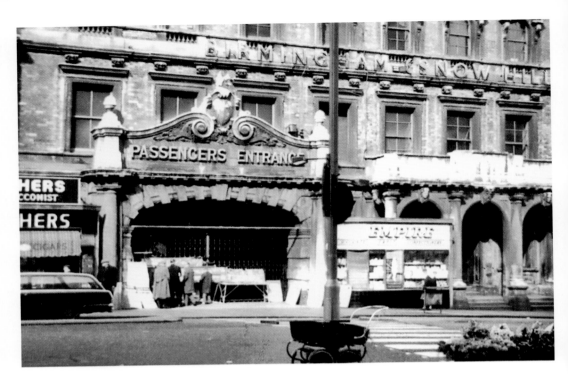

Snow Hill Station

The Old Snow Hill station's ornate stone 'passengers' entrance' on Colmore Row has witnessed many thousands of people passing through to journey all over the country. Today the passengers using the new station entrance are obliged to pass the large amount of modern glazing that adorns the buildings that now surround the station.

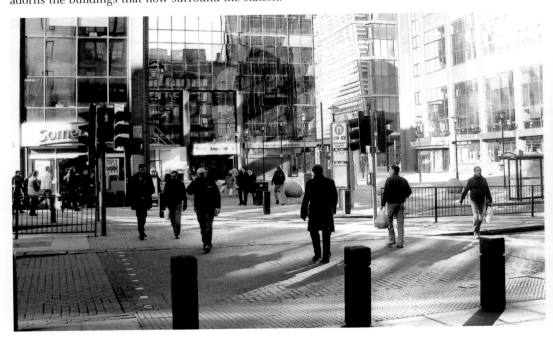

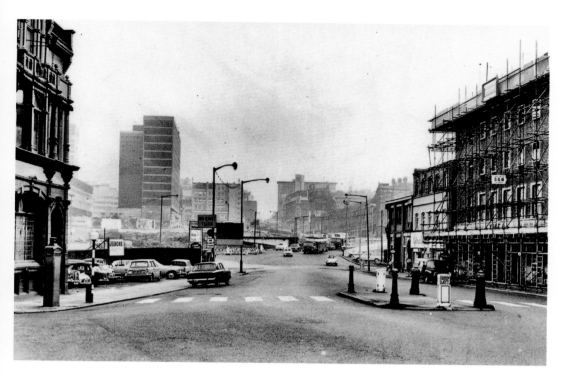

Snow Hill

Approaching Snow Hill in the 1960s, from Constitution Hill, with the Salutation public house and a blue police phone box occupying the corner of Summer Lane a landscape of redevelopment greets you. Fifty years later a sky line of towering buildings, some still under construction, has the A38 Queensway tunnel passing under and St Chad's Roman Catholic Cathedral on the left.

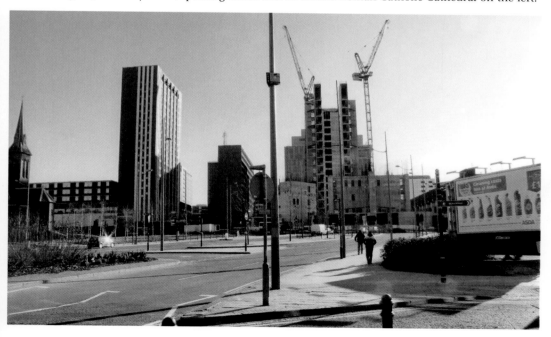

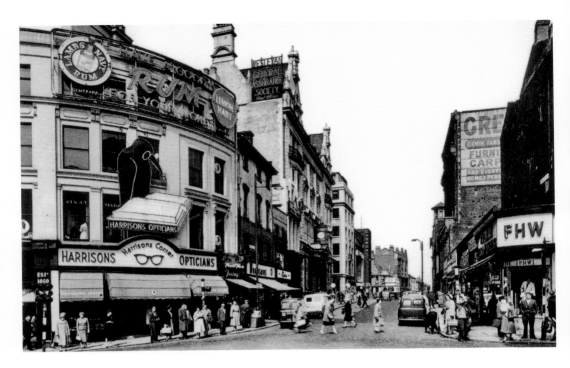

A Busy Junction

A busy shopping area at the junction of Steelhouse Lane, Bull Street, Colmore Row and Snow Hill has been replaced by high rise office blocks and multi-storey car parks. Looking down Steelhouse Lane in the early photograph the Gaumont cinema is on the left. The building opened in 1931 and was closed in 1983 then demolished in 1986. The Wesleyan Insurance Company now occupies the site.

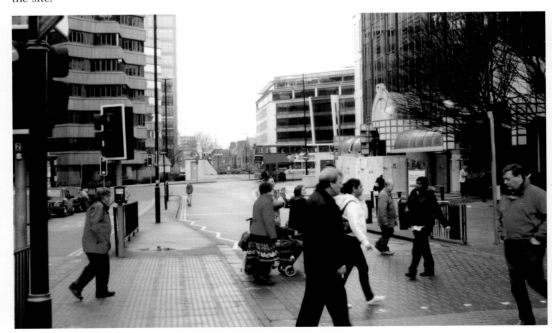

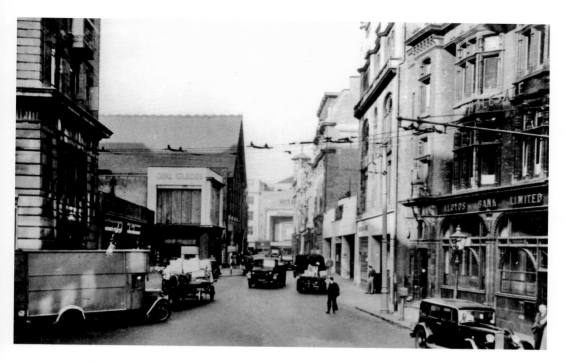

Upper Priory

Upper Priory was a busy thoroughfare with Lewis's store, Lloyds bank and the Gaumont cinema in Steelhouse Lane at far end. Today approached in the opposite direction towards the Old Square large modern buildings stand side by side with the old Lewis's building at the far left. At Christmas time before Lewis's store closed, children with their parents queued around the Old Square waiting to see Father Christmas.

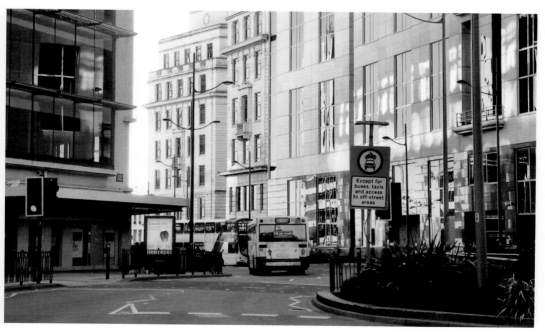

The George and Dragon

The George and Dragon public house stood on the corner of Weaman Street and Steelhouse Lane where numerous shops selling guns, machine tools and various other manufacturing goods were located. Following the redevelopment of Steelhouse Lane with its bright modernistic looks, it's like walking through a forest of glass. Weaman Street now runs to the right at the end of this view.

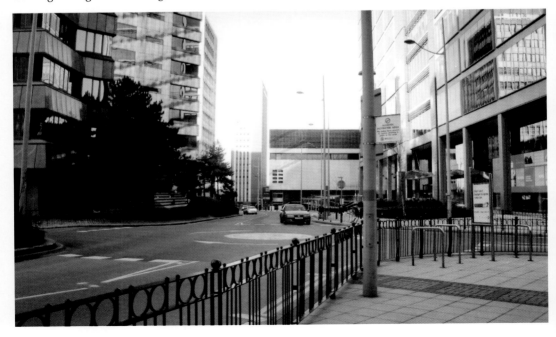

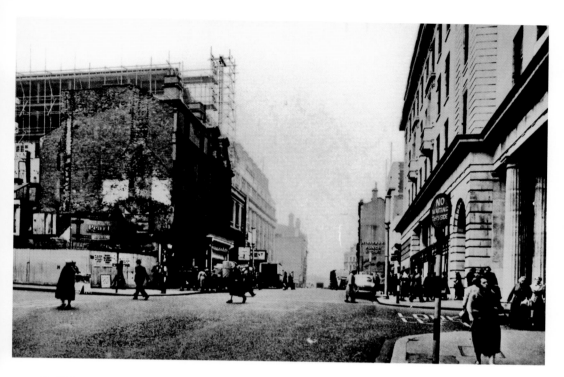

Bull Street

A piece of disused land has been boarded up on the corner of Temple Row and Bull Street where a little further on construction work is being carried out on the buildings. Snow Hill can clearly be seen at the far end of Bull Street in the old photograph but after redevelopment Bull Street has taken a different line blocking the Snow Hill view.

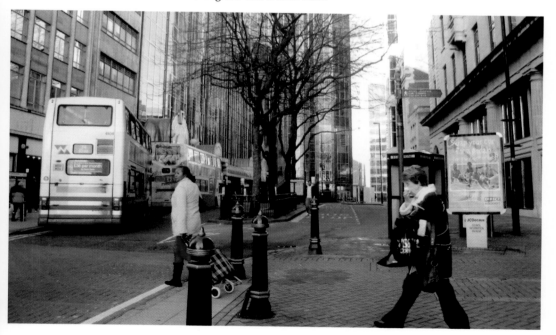

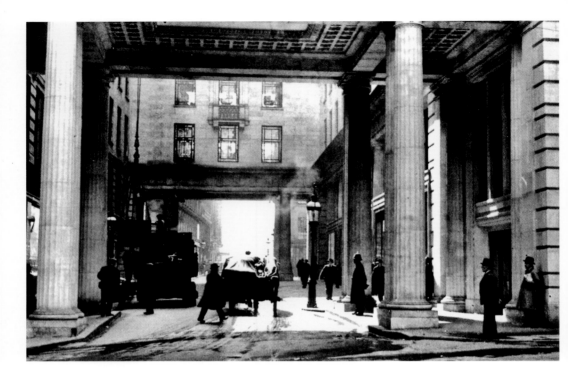

The Minories

The main entrances to Birmingham's largest department store, Lewis's which opened in 1885 was on the left and right after passing through the Doric columns at the Minories. This unique public road with its experimental rubber block surface ran the short distance from Bull Street to Old Square under the upper floors of the department store. Lewis's ceased trading in the 1990s but the building viewed from Temple Row in 2010 still exists.

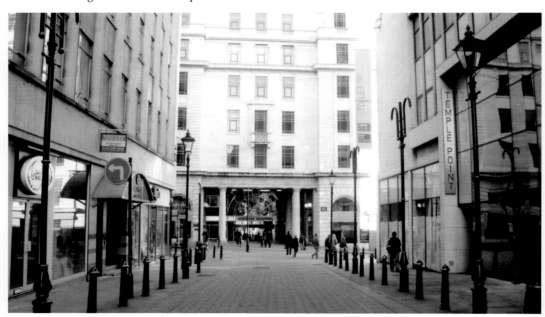

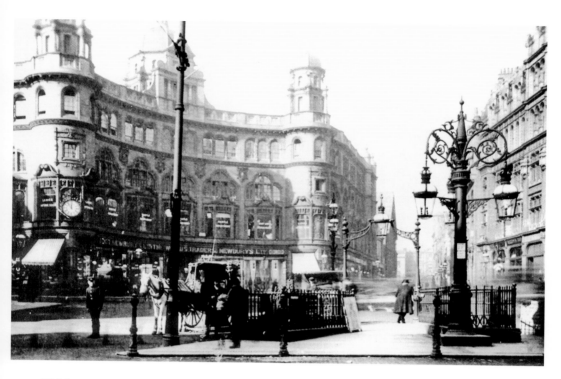

Old Square

Over the years the buildings and appearance of the Old Square has changed a few times. In the days of horse drawn vehicles the buildings were grand, matching the status of the emerging city. The other side of the Lewis's building and the Minories seen in the modern photograph continue to be equal to the buildings of yesterday by maintaining a certain prominence.

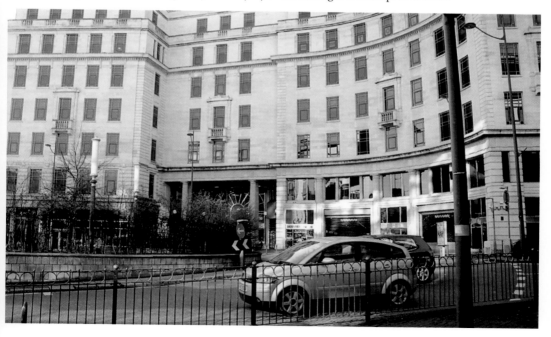

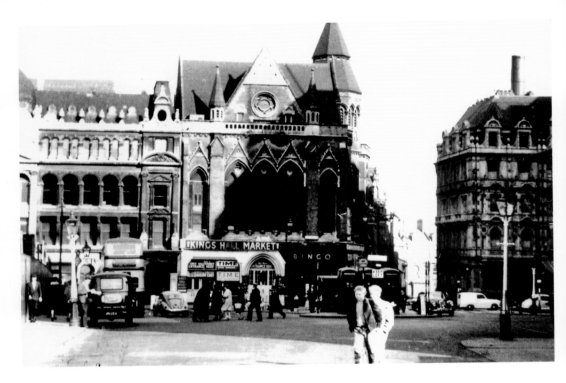

Kings Hall Market

Kings Hall Market Corporation Street viewed from the Old Square in the 1950s surrounded by the prominent Victorian buildings of this street. The same view in 2010 exposes a completely changed environment with the old buildings having been replaced by modern high rise structures with shops below.

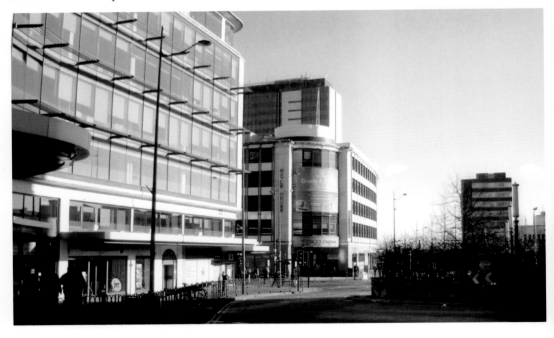

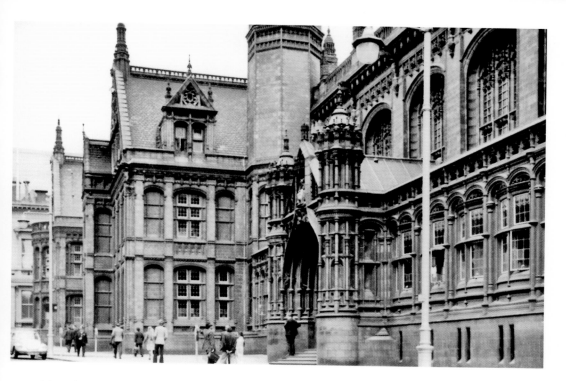

Victoria Law courts

Victoria Law Courts stand out from the other magnificent buildings in Corporation Street by the red brick terracotta exterior. This majestic Victorian structure was opened in 1891 by the Prince and Princess of Wales. The court business has now moved to new premises called the Queen Elizabeth II Law Courts in nearby Newton Street but a traffic warden is still looking for business outside the old law courts.

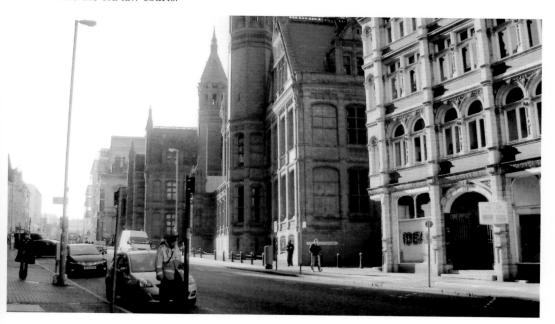

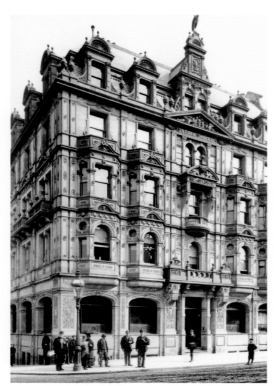

Two Hotel Buildings

The Stork Hotel opened in 1883; five years later this entry appeared in an 1888 trade directory for Birmingham, "Stork Hotel Family & Commercial, Corporation Street, John Horton Tailby proprietor, Stock and show rooms ..." this hotel has subsequently been demolished. The Crown Hotel building also in Corporation Street on the corner of Newton Street has survived where the upper floors are occupied by the offices of solicitors and criminal lawyers aptly placed with the Queen Elizabeth Law courts in Newton Street nearby.

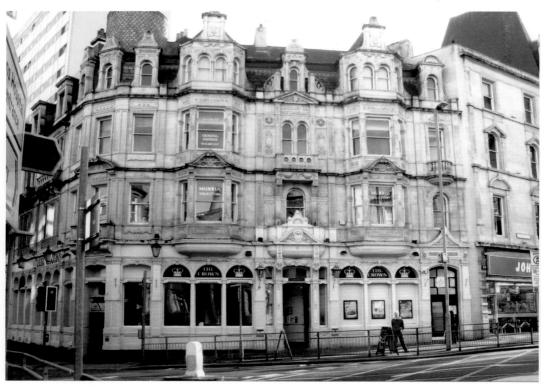

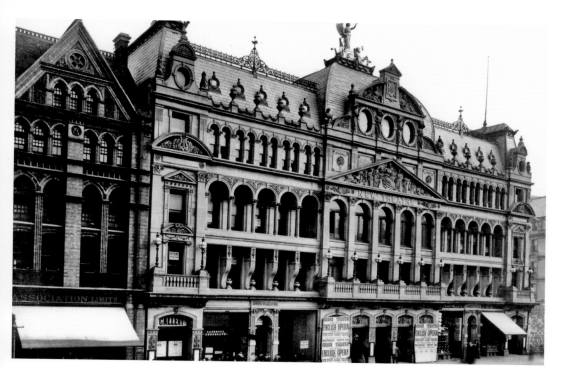

The New Theatre and Central Hall

The New Theatre opened in November 1883 and was located next to the old Central Hall (renamed to King's Hall) in the Old Square. Both buildings witnessed numerous conversions, the New Theatre was renamed the Grand. The Grand was renamed 'The Grand Casino Ballroom' before its demolition in 1960 for the construction of The Priory Queensway. Further down Corporation Street the new Methodist Central Hall that opened in 1887 is on the right, a red brick terracotta Grade II* listed building with a distinctive tower.

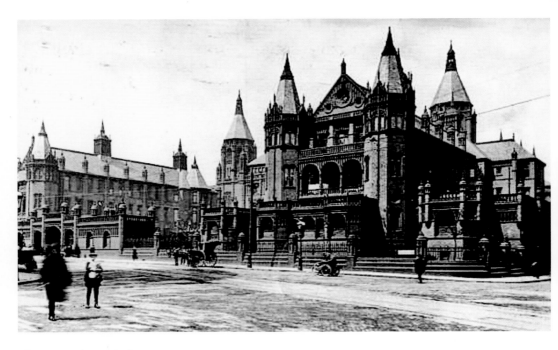

The General Hospital

A postcard showing the General Hospital Birmingham which opened at the far end of Steelhouse Lane in 1897 replacing the Summer Lane building that dated from 1779. The hospital underwent a change of use in 1998 when the Birmingham Children's Hospital was transferred from Ladywood to the Steelhouse Lane site. In 2010 the building still has the same appearance as it did over one hundred years ago.

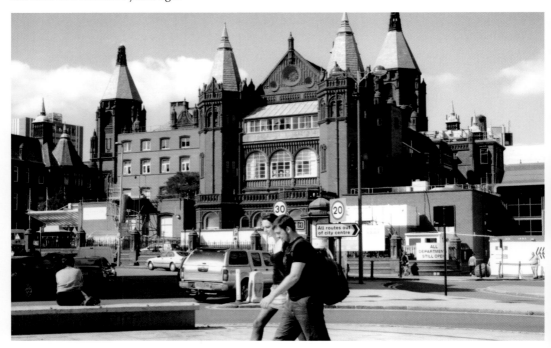

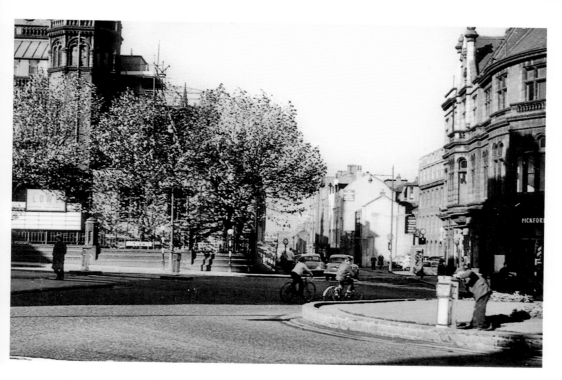

Loveday Street

A 1950s photograph taken at the bottom of Steelhouse Lane where the General Hospital occupies the corner with Loveday Street. Another hospital building, the Birmingham Maternity Nurses' Hostel is on the right in Loveday Street just past The Bull public house on the corner of Price Street. Today The Bull stands alone following the demolition of the gun quarter whose workers once frequented the pub.

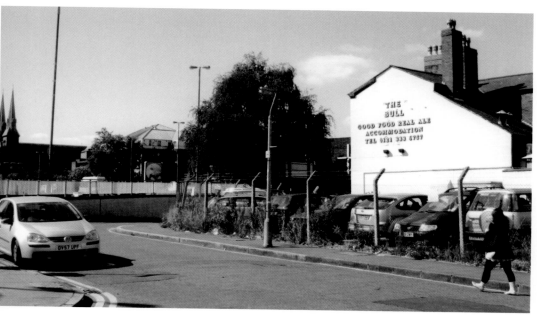

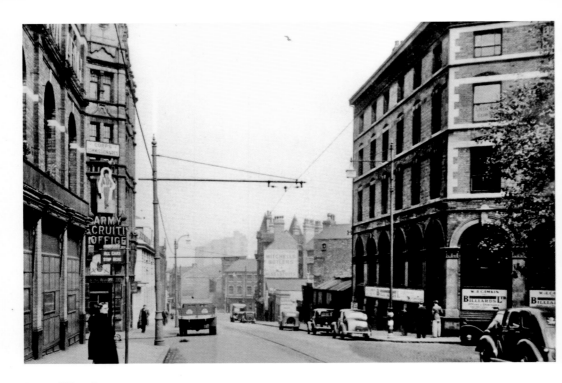

James Watt Street

Bringing the traffic, up town, from Perry Barr and Aston along the James Watt Queensway with its high rise tower blocks and other types of modern buildings contrasts greatly with that of another period. In the earlier photograph of James Watt Street, named after the famous engineer, there is an army recruiting office on the left and a lady waiting for a tram. This street once led down to Stafford Street.

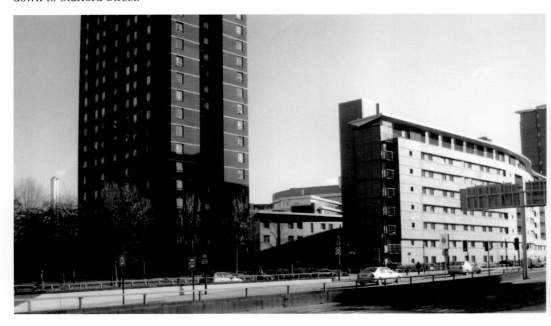

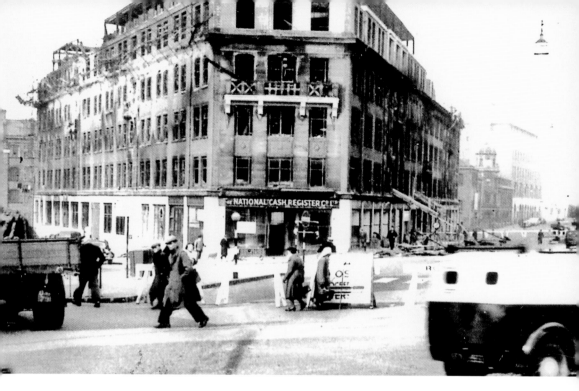

Aston Street

Firemen attending a fire at the Halfords Building that housed the National Cash Register building on the corner of Corporation Street, further down towards Aston is the King Edward Inn and The Ministry of Labour building. The central fire station was also on a corner of Corporation Street and Aston Street Gosta Green.

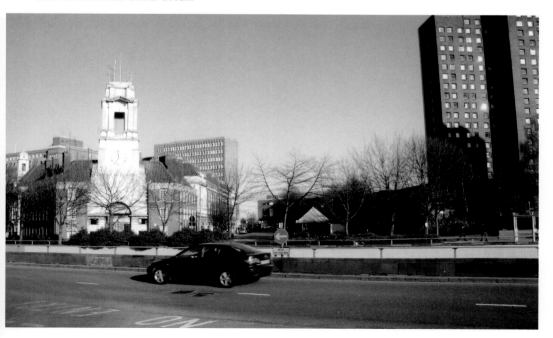

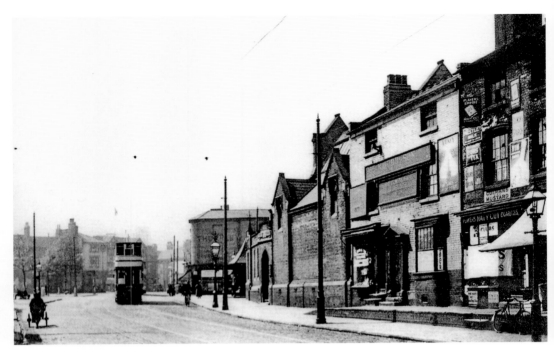

Gosta Green

Houses and shops in the small working class district of Gosta Green situated on the edge of central Birmingham with Aston Street and Aston Road running through has been absorbed by the Aston University complex.

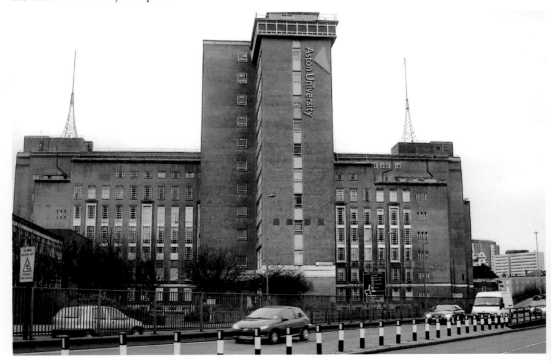

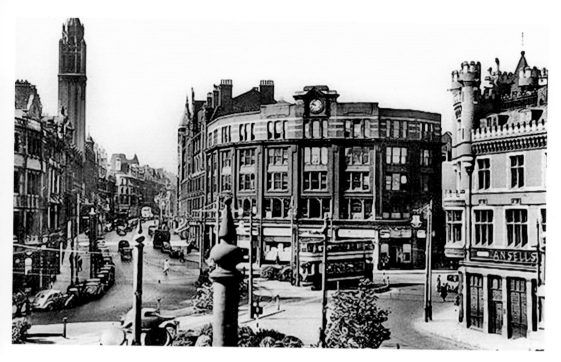

Lancaster Place

Lancaster Place from Aston Road was a multi tramway junction/ island with The Castle public house on the right corner of Steelhouse Lane and Loveday Street with Corporation Street on the left. King Edward building is central where Hawkins cotton manufacturer was situated, many Birmingham housewives shopped there for curtains and drapes. The King Edward building with the Rotunda behind still graces this area now known as Lancaster Circus Queensway.

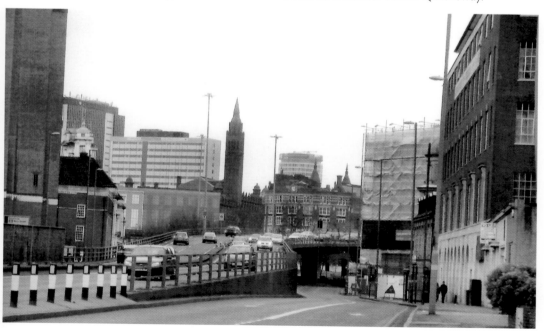

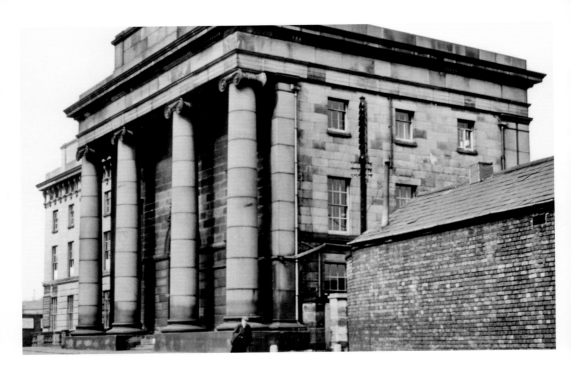

Curzon Street Station

Birmingham's first railway station opened in 1838 at Curzon Street for the London and Birmingham Railway Company linking Birmingham with Euston. It was short lived as a passenger station due to its location however it remained in use as a goods station until it finally closed in 1966. This Grade I listed building stands isolated in 2010 awaiting the regeneration of Birmingham's West Side.

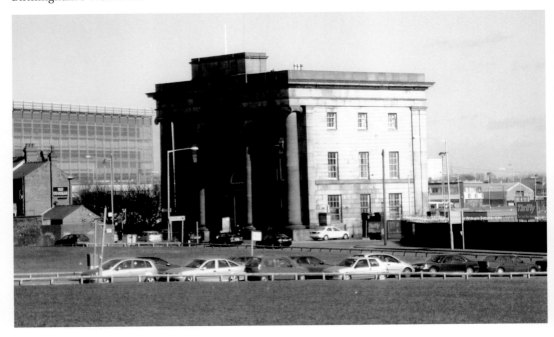

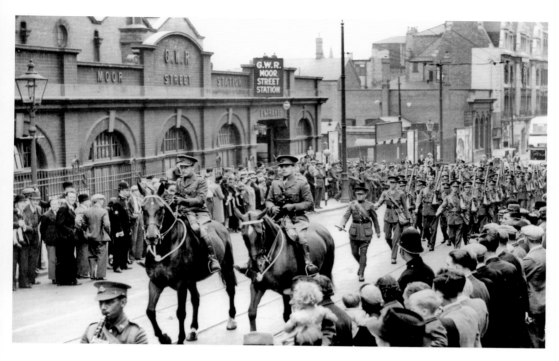

Moor Street

This old photograph was taken in 1939 in Moor Street and sent to Captain R. W. Lowe, Adjutant, Aston Barracks, Witton, Birmingham, now part of the Aston Villa Football Club. The Warwicks are disembarking from the station probably to Witton Barracks. Moor Street has been realigned and now bends around the station that has recently been refurbished.

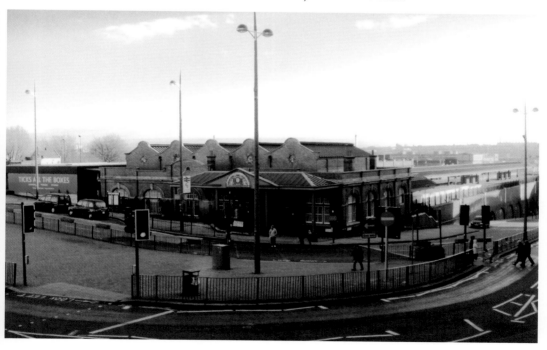

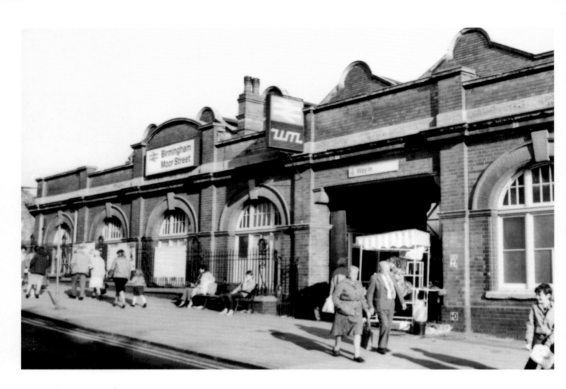

Moor Street Station

Moor Street station first opened in 1909, one of three railway stations in Birmingham. The old and new photographs reveal the changed face of this Grade I listed building that has recently been refurbished in a 1930s style. Outside the station the controversial disks overlooking the station on the side of the Selfridges new store are anything but 1930s.

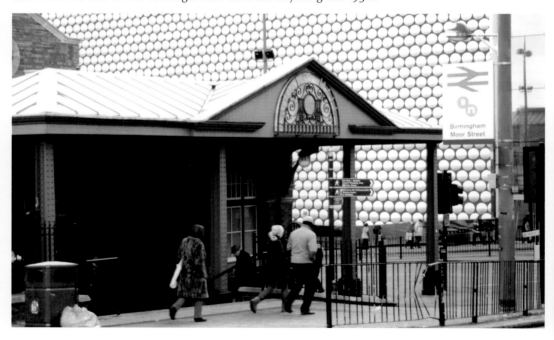

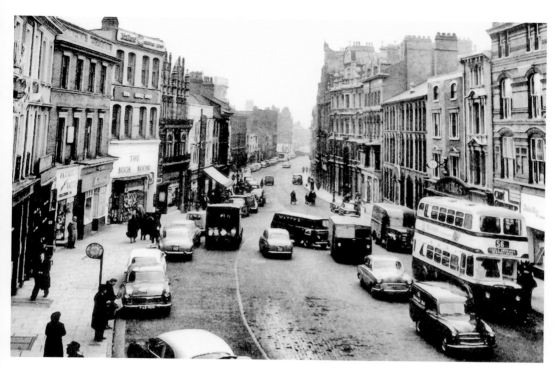

Dale End

Dale End was a very busy route in and out of Birmingham, now replaced by several high rise buildings and Masshouse Circus. The road was named after Dr Robert William Dale a nonconformist minister from Carrs Lane church.

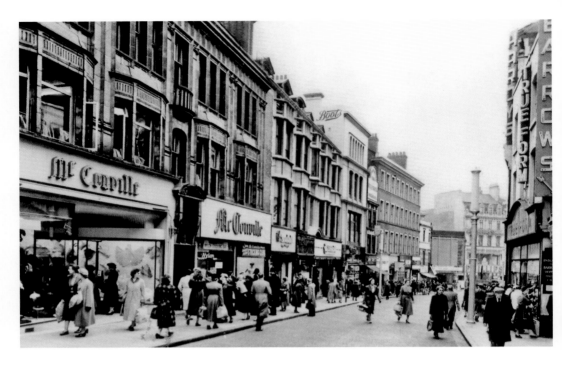

Bull Street

Many shops of note had been established in Bull Street when this early photograph was taken showing a rare sight in Birmingham of shoppers shopping in a traffic free road that was Bull Street. Alfred Bird (Bird's Custard) had his first shop here, later moving to Digbeth. At the bottom end of Bull Street was Dale End and the News Theatre. Today most of the shops have been replaced by modern buildings.

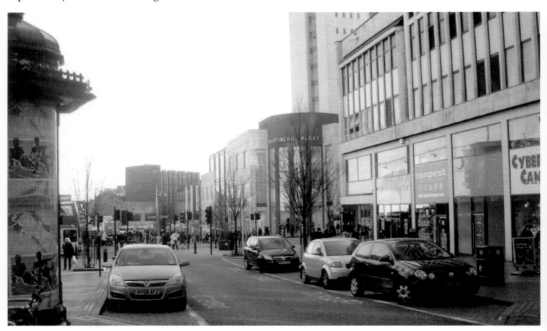

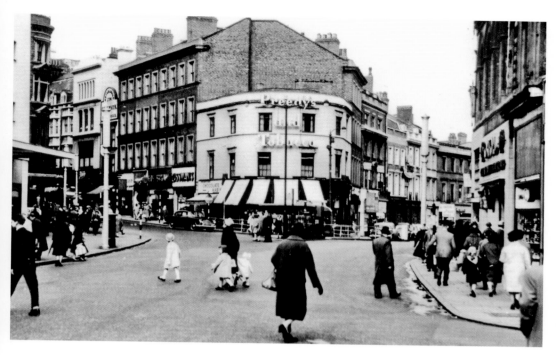

High Street

A sign displaying Preedys and Tobacco overlooks High Street from the building on the corner of Bull Street and Dale End where shoppers amble around in a road free of any traffic. In 2010 the Pavilions shopping centre and large stores like WHSmith and Waterstones have replaced the smaller shops and the High Street has been pedestrianised.

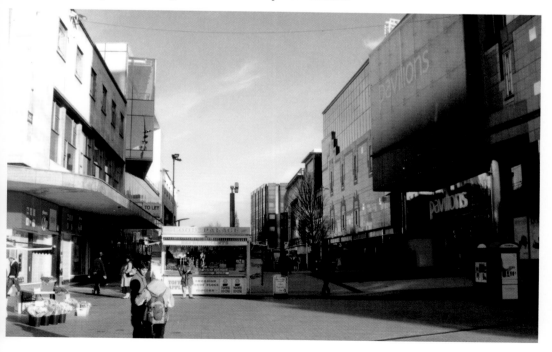

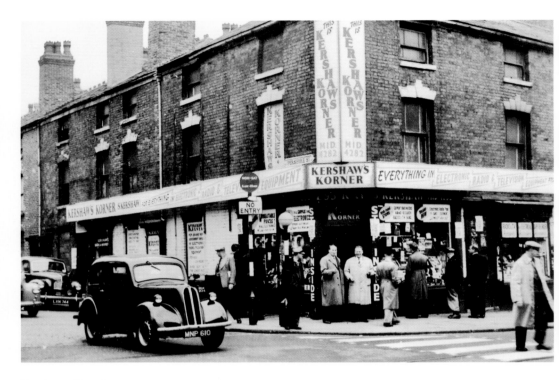

Pershore Street

At the Bullring end of Pershore Street in 2010 Debenhams store is located facing the Dudley Street tunnel. Running above the tunnel is the elevated Smallbrook Queensway and above that a footbridge displaying the words Bullring. To achieve this hundreds of back-to-back terrace type houses and small businesses were demolished like Kershaw's Korner also in Pershore Street.

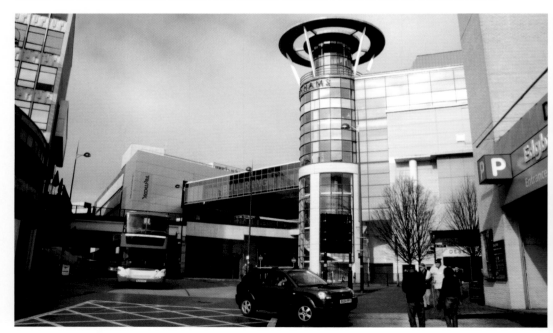

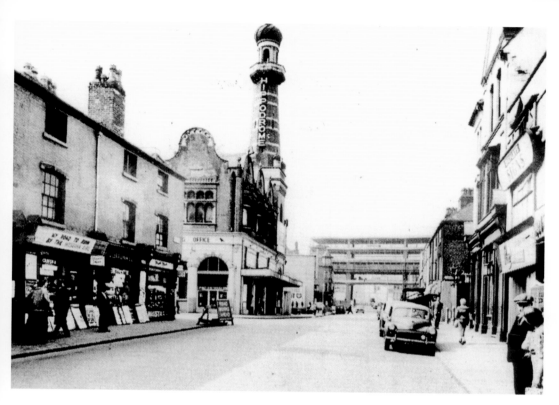

Hurst Street

Not all the old premises were demolished
in the 1960s redevelopment of Hurst Street.
Still remaining next to the new Birmingham
Hippodrome are the National Trust back-to-
back houses that have been restored and a
museum created in 2005.

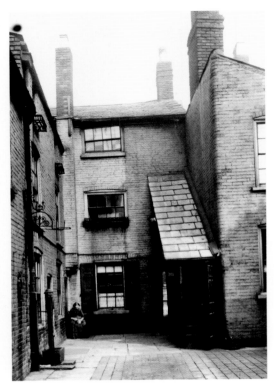

Back-to-Back

Part of the surviving back-to-back properties in Hurst Street are accessed via an entry (passageway) in Inge Street where three more houses are located in a court yard that also houses the shared domestic facilities used by all the families. This type of working class housing once existed throughout Birmingham; one example is in the early photograph of a courtyard in Digbeth.

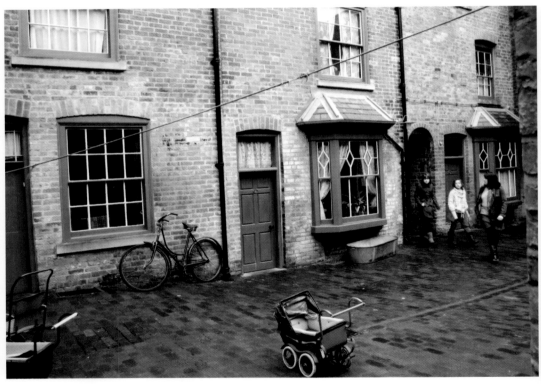

Bull Ring Market

Two periods of time in the life of the Birmingham Bull Ring market the first one was taken following the creation of the 1960 version where the outdoor market was located below the road level. The second photograph was taken on Saturday 20 February 2010 that shows the latest home of the outdoor Bullring market.

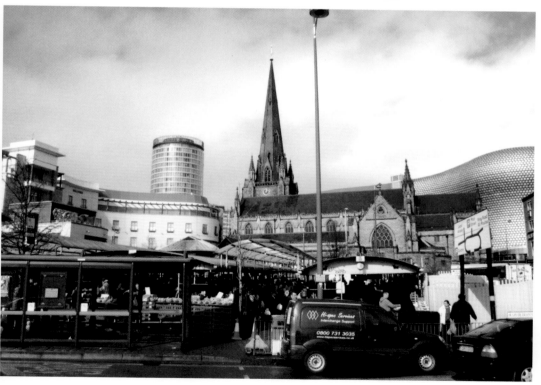

Acknowledgments

The authors of *Birmingham Up Town Through Time*
Ted Rudge www.winsongreentobrookfields.co.uk
John Houghton www.astonbrook-through-astonmanor.co.uk
Mac Joseph http://www.oldladywood.co.uk/
Each have their own Birmingham local history web sites dedicated to preserving the memories of their readers since 2002. However the completion of this book has been made possible by the generosity in time and materials from many people and if any are missed in this acknowledgment we apologise.

We thank the following people and web sites who have helped in this project.
Professor Carl Chinn; http://lives.bgfl.org/carlchinn/
For allowing us to use photographs from the 'Carl Chinn Archive' and for writing the Foreword to this book. To Keith Clenton for the use of his personal collection of modern Birmingham photographs. The people who contributed from the Ted Rudge, John Houghton and Mac Joseph websites. Ted's wife Maureen for providing the title, proof reading the text and encouragement with the project. Mac's wife, Pauline for all her support and help with the photographs and captions. John's wife June for accompanying him on the photographic visits and making notes. Susan, Ted and Maureen's daughter, for accompanying Ted on the uptown visits to take the photographs and making notes used in the captions.

Dennis John Norton
http://www.photobydjnorton.com/index.html
Birmingham History forums
http://birminghamandsuburbs.com/forum/
http://forum.birminghamhistory.co.uk/forum.php

We would also like to thank Amberley Publishing for giving us the opportunity to produce this local history book describing some of the Birmingham up town changes displayed in *Birmingham Up Town Through Time* and to everyone who reads the book we trust it rekindles memories the way it was or still is for you.

Ted Rudge MA, John Houghton and Mac Joseph

Other Birmingham Through Time Amberley Publications

Winson Green to Brookfields Through Time by Ted Rudge
In and Around Ladywood Through Time by Ted Rudge
In and around Aston Through Time by Ted Rudge & John Houghton